Bald Eagles
The Ultimate Raptors

Written and Photographed by
STAN TEKIELA

Adventure Publications
Cambridge, Minnesota

Dedication

To my mother, whose love and support has allowed me to soar with the eagles.

4

Acknowledgments

I would like to thank the National Eagle Center and all its staff and volunteers, whose extensive knowledge of Bald Eagles has contributed to the accuracy of this book. Your dedication to educating the public about eagles is unsurpassed. Special thanks to the staff and volunteers at The Raptor Center, College of Veterinary Medicine at the University of Minnesota, for all the hard work rehabilitating injured raptors and reaching out to the public with educational programs.

Thanks!

Cover photos by Stan Tekiela
All photos by Stan Tekiela except page 15 by Pavel Nekoranec on Unsplash; page 16 by Ryunosuke Kikuno on Unsplash; page 19 by Patterson, Richard Sharpe. Great Seal of the United States, from *The eagle and the shield: a history of the great seal of the United States. Washington: United States State Department, 1978*; page 109 (top left) by Susan Hodgson/Shutterstock; page 117 (both) courtesy of Raptor Resource Project–2020, www.raptorresource.org; and page 139 (top image) by Dominique Braud.

All photos were taken in the wild except for 41, 84, 94, 98, 106 and 128, which were taken under controlled conditions.

Edited by Sandy Livoti and Brett Ortler
Cover and book design by Stephen Sullivan

10 9 8 7 6 5 4 3 2 1
Bald Eagles: The Ultimate Raptors
First Edition 2007 (entitled *Majestic Eagles*)
Second Edition 2021
Copyright © 2007 and 2021 by Stan Tekiela
Published by Adventure Publications
An imprint of AdventureKEEN
310 Garfield Street South
Cambridge, Minnesota 55008
(800) 678-7006
www.adventurepublications.net
Printed in the United States of America
ISBN 978-1-64755-145-2 (pbk.); 978-1-64755-146-9 (ebook)

Contents

The majesty of eagles

If you've ever seen an eagle fly gracefully over an unbroken forest or watched it snatch a fish from the surface of a crystal-clear lake, you probably experienced the same inspirational feeling that has touched people throughout the ages. From ancient days to current times, the eagle has been greatly admired. It has also played an important role in the history of many cultures.

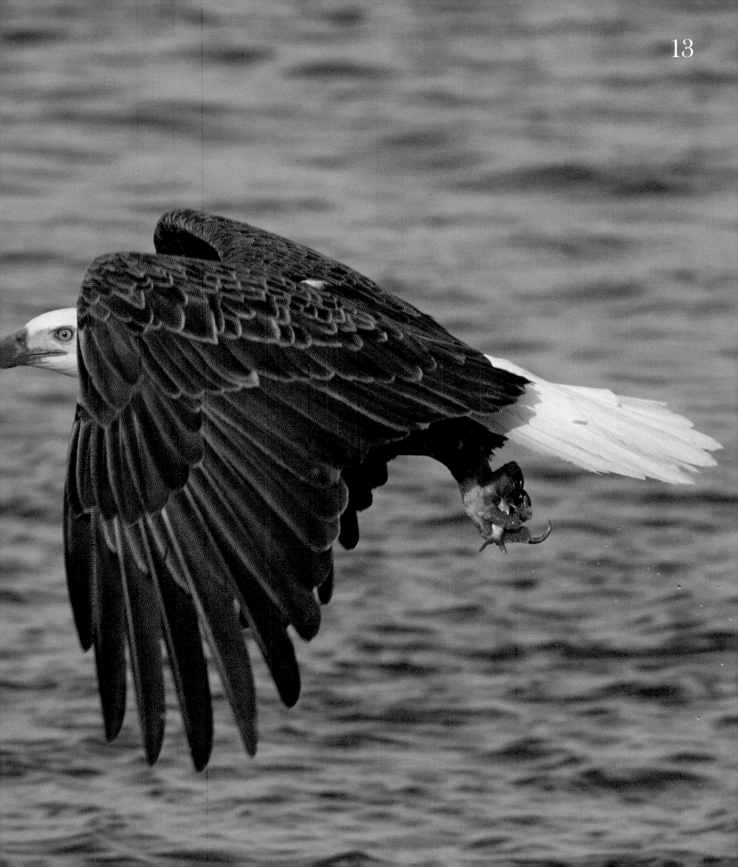

A symbol through the ages

Greek and Roman legends claim that only the eagle had enough speed of flight and strength in its talons to snatch thunderbolts away from their god kings (Zeus and Jupiter, respectively). With stories like these adding to its image, the eagle became synonymous with power, skill and cunning in many cultures.

An eagle was used in ancient Egypt to symbolize the goddess Nekhbet, who was the eagle deity. She was considered the protector of the Pharaoh by spreading her wings.

The eagle that influenced the history of these nations, however, was not the Bald Eagle. Ancient cultures and Europeans were familiar only with the Golden Eagle and several other eagle species found throughout the world. Unknown to Asia, Africa, Europe and the rest of the Old World, the Bald Eagle is native solely to North America.

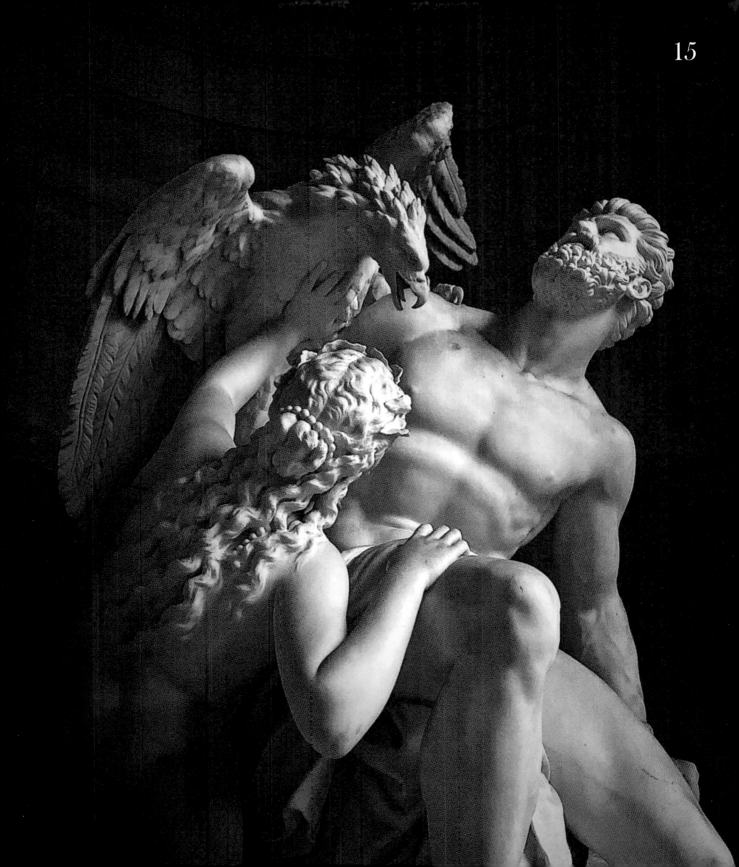

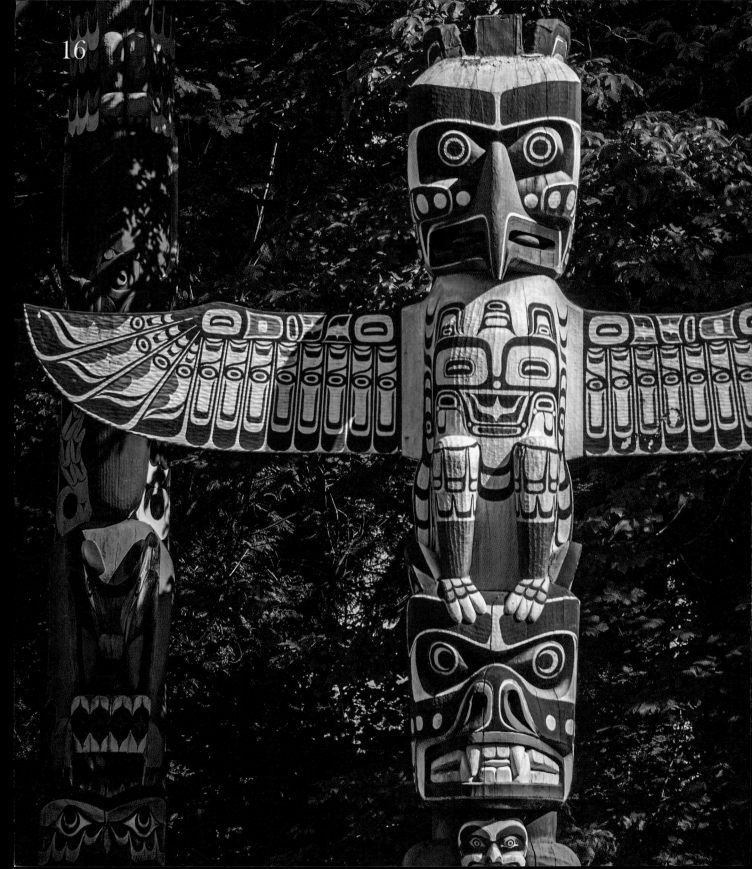

American Indian mythology

It's no surprise that in the past, American Indians had seen the beauty of the Bald Eagle and chose it for their symbols, often carving its image into totems. Many tribes adopted it as a symbol of honor, achievement, leadership and bravery.

Comanche Indians tell a creation story about a chief's young son who died. After the father offered prayers, the boy came back to life as a large and powerful bird—the first eagle. The Comanche eagle dance celebrates this colorful legend.

In other American Indian cultures, the Bald Eagle serves as an intermediary between the Creator and the people. Pawnee Indians saw the Bald Eagle as a symbol of fertility because eaglets, in their large nests high off the ground, were safe and well protected from intruders and were thriving.

Eagle feathers remain highly revered in American Indian culture today. Regarded as holy objects, they are used in many American Indian religious ceremonies.

It is important to note that strict federal and state laws prohibit the owning, selling or trading of any Bald Eagle feathers or body parts. Please be informed of laws and be respectful of eagles, reporting abuses you witness to the proper authorities.

The eagle in US history

We have our own modern history with the Bald Eagle. The United States first adopted the Bald Eagle as its national symbol in 1782, depicting it on the Great Seal of America.

Many of our founding fathers revered the Bald Eagle. Thomas Jefferson said the eagle was "a free spirit, high soaring and courageous." The same did not apply to Benjamin Franklin, who wrote, "I wish the Bald Eagle had not been chosen as the representative of our country. He is a bird of bad moral character."

Interestingly, famed naturalist John James Audubon did not like the Bald Eagle either. He wrote, "They exhibit a great degree of cowardice. Suffer me, kind reader, to say how much I grieve that it should have been selected as the emblem of my country." However, on a trip up the Mississippi River in 1814, Audubon, apparently unfamiliar with the dark plumage of the juvenile Bald Eagle, misidentified one. Thinking he had discovered a new eagle species, he named it Washington Sea Eagle in honor of George Washington, describing it "the mightiest of the feathered tribe." Audubon clearly liked this new bird, but not the adult Bald Eagle. There is no record of his comments upon finding out the new eagle was just a juvenile Bald Eagle.

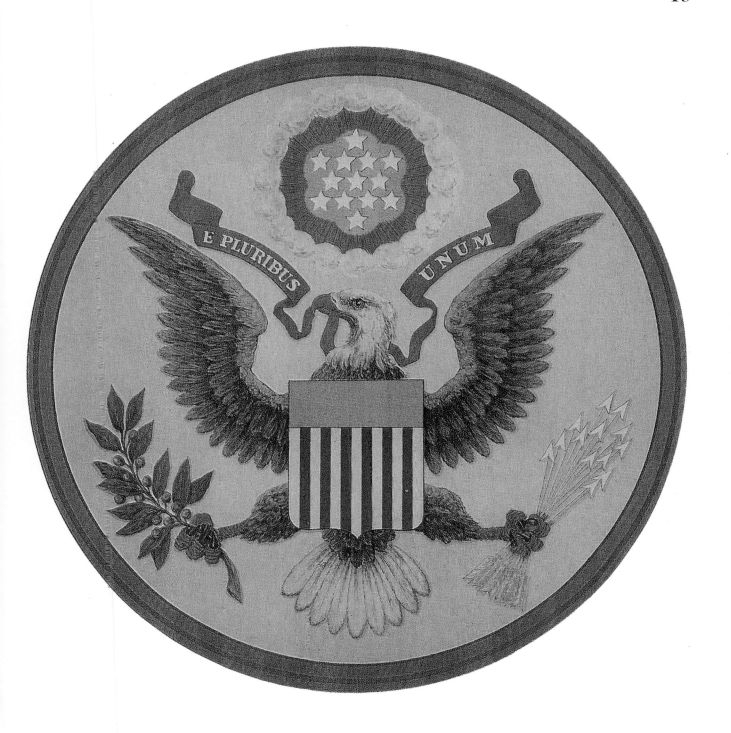

Get to know North American eagles

If you have a clear look at an adult bald eagle soaring overhead, identifying it is often relatively easy. But if you don't get a good look at it, you spot it perched at a distance, or you see a juvenile eagle, it can be hard to identify it. Here's an at-a-glance look at eagles, juvenile eagles, and their look-alikes.

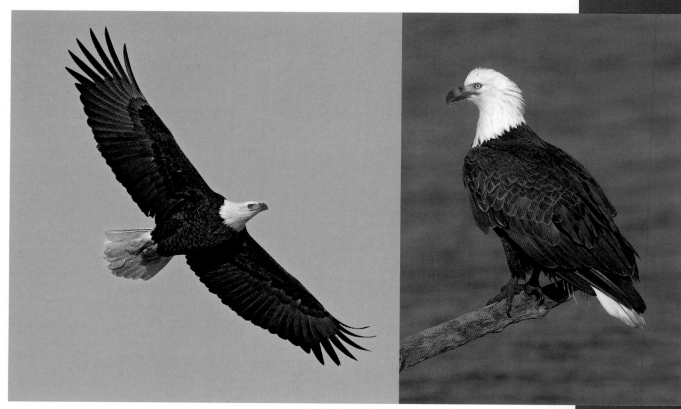

Bald Eagle

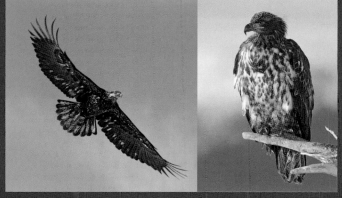

Bald Eagle

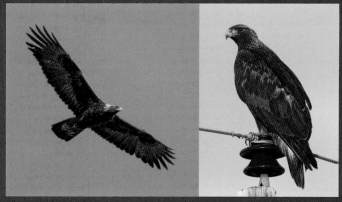

Golden Eagle

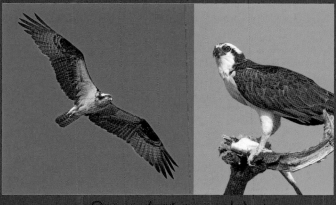

Osprey (not an eagle)

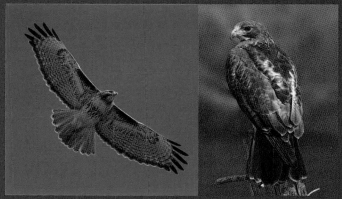

Red-tailed Hawk (not an eagle)

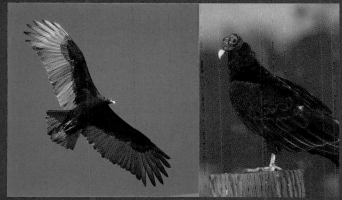

Turkey Vulture (not an eagle)

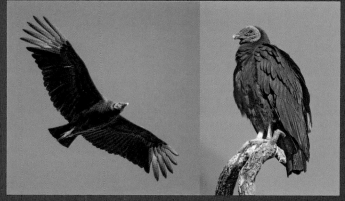

Black Vulture (not an eagle)

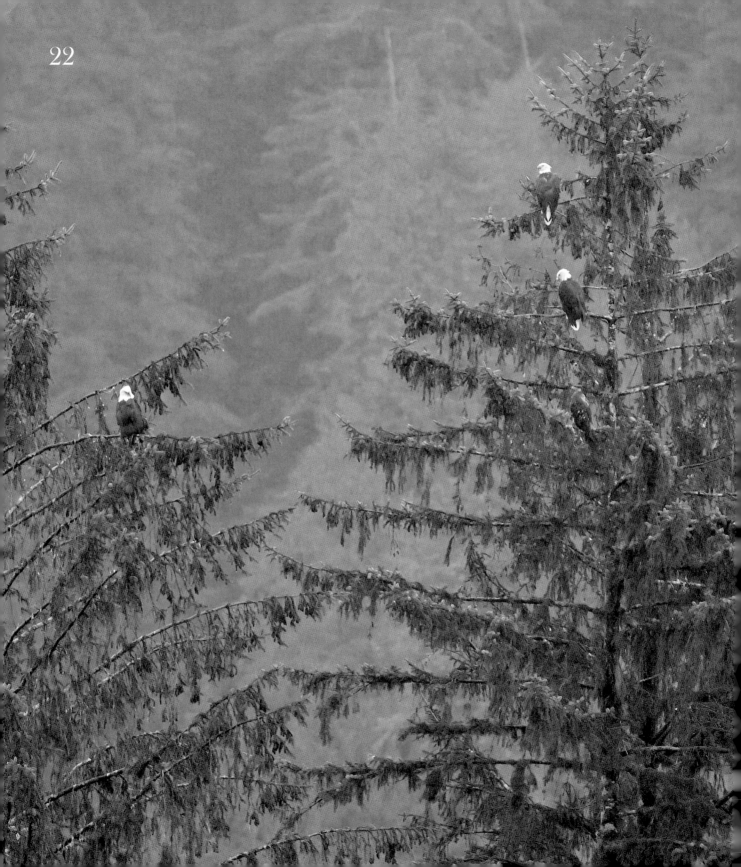

Where to spot eagles

Perch sites. These tall, often dead, trees offer an uninterrupted view of the terrain, making it easier for the eagle to spot food sources from a distance.

Nesting sites. Similar to perching sites, eagles are often seen near their nests, even when it's not breeding season; they do so because the nest site is often in a tall, protected space, and they often want to protect their territory from potential interlopers.

Near carrion on roadsides or in farm fields. Eagles are opportunistic feeders, and they'll feed on carrion, such as dead rabbits or deer on roadsides, or in farm fields. This can prove quite a surprise to motorists coming around the bend to spot an eagle just feet away.

Soaring overhead. This is no doubt how eagles are spotted most frequently; eagles soar for a number of reasons, not least because it's efficient and affords them a perfect view of the surroundings, enabling them to find food and monitor their territory.

Along rivers or bodies of water. In winter, eagles often stick around as long as there is open water, as this enables them to find food more easily; this also leads some places, including the Mississippi River Valley, to become eagle hotspots, where it's not uncommon to spot many eagles in a relatively small amount of space.

In surprising places. If there is a ready food source, such as at a fishing harbor or a garbage dump, you might find many eagles all at once.

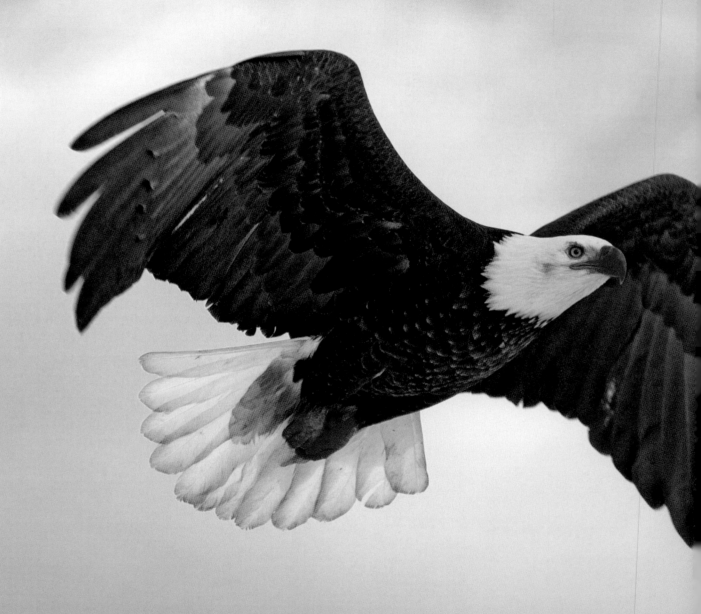

Popular names

Through history, the Bald Eagle has also been called the Fish Eagle, Black-and-Brown Eagle, White-tailed Eagle, Washington Eagle, Washington Sea Eagle, American Eagle, American Bald Eagle and Bald-headed Eagle. It is now officially called the Bald Eagle.

Origins of the common name

Obviously, the Bald Eagle is not bald, but the white head and neck of the adult bird does give it a bald appearance. Appearing bald, however, is not the reason for the first part of the common name. Back in Middle English times, the word *ballede* was synonymous with "white" or "shining white," not hairless. Either way, "Bald" in the name seems to be appropriate.

"Eagle" came from the Latin *aquilus*, which means "dark" or perhaps "the north wind," which brought dark storms—altogether it meant "the black eagle."

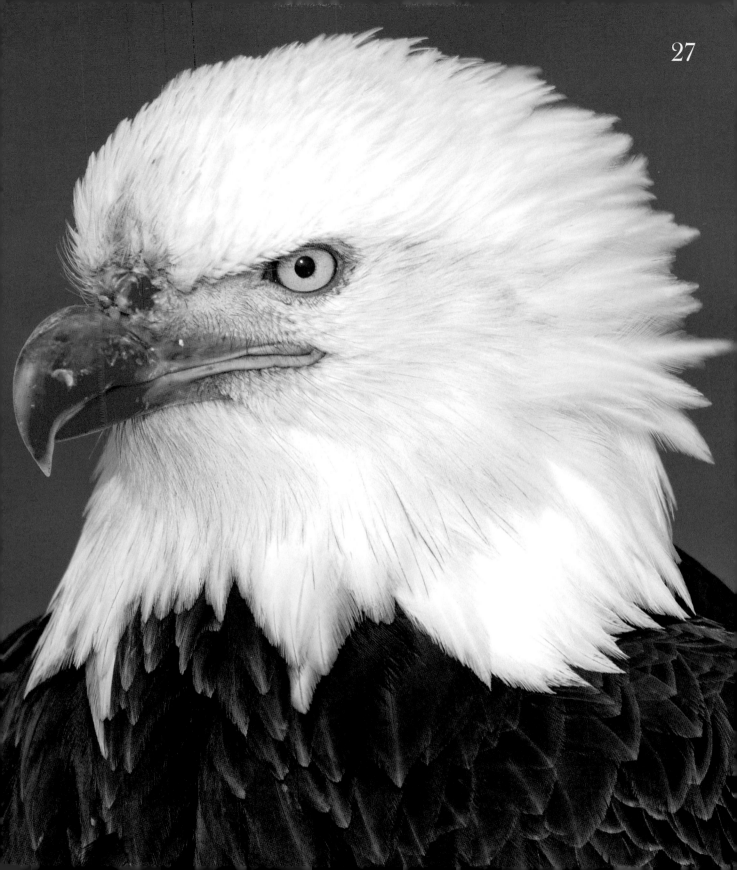

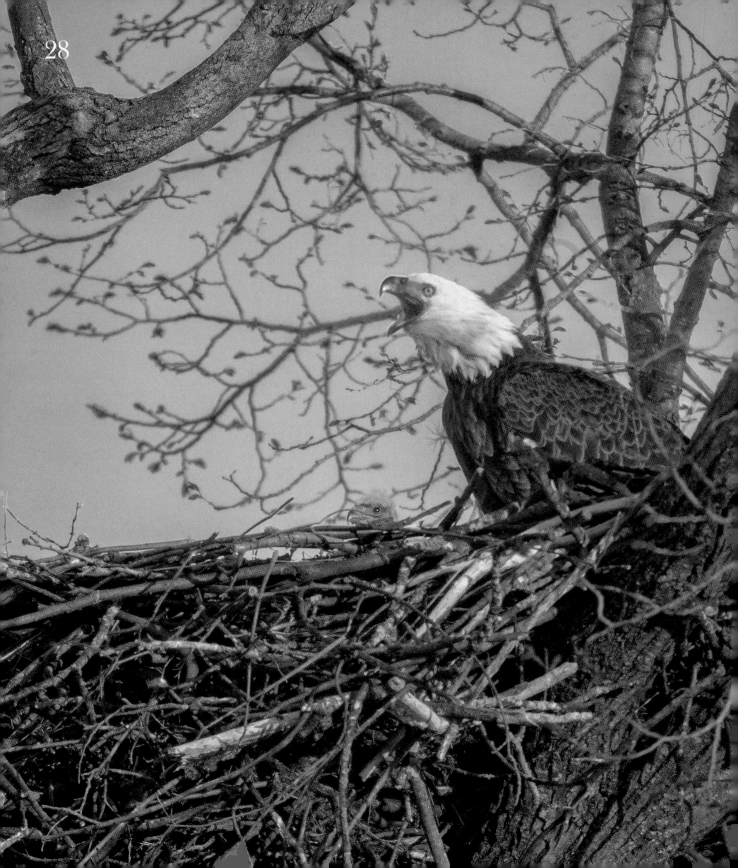

Origins of the scientific name

The scientific name of the Bald Eagle is *Haliaeetus leucocephalus*. The genus Haliaeetus is Greek and breaks down into *Halos*, meaning "the sea," and aetos, translating to "an eagle," referring to the fact that the Bald Eagle is member of the Sea and Fish Eagle group.

Range from coast to coast

The Bald Eagle is truly an American bird. In the right habitat, it can be found all over the United States. Its range spans across most of Alaska, through Canada to the tip of Florida, Texas, California and into Mexico. Bald Eagles in the southern part of the range tend to be 10 percent smaller than their northern counterparts, with shorter wings and 20 percent shorter tails. At one time in the past, these differences constituted a subspecies. Because populations of northern and southern birds were found to be intertwining, they were classified into one species—although juvenile Bald Eagles (as shown) are still sometimes mistaken for Golden Eagles.

Bald and Golden Eagles

Bald Eagles are not closely related to our other native eagle, the Golden Eagle. Goldens are usually found far from water, often in mountainous regions, feeding mainly on rabbits, hares and other small- to medium-sized mammals. The Bald Eagle is usually associated with water, making its living by fishing and chasing waterfowl such as the Mallard. However, increasing populations of Bald Eagles have forced many other Bald Eagles away from water, to eke out a living on roadkill animals such as deer, squirrels and rabbits in less prime habitats.

opposite: Golden Eagle

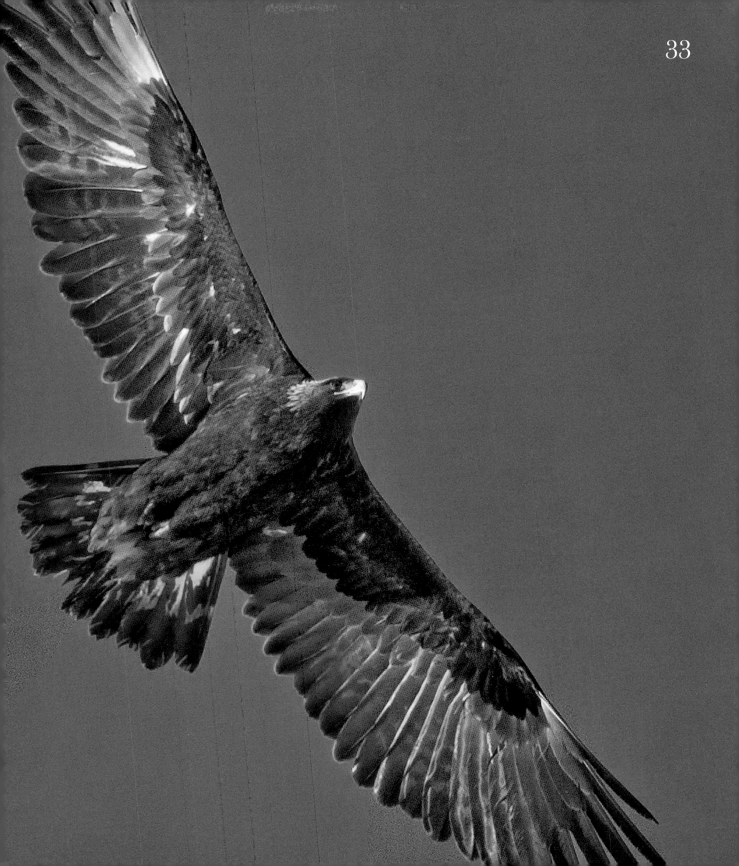

Help from the Osprey

The reintroduction and subsequent increase of another native bird of prey—the Osprey—has inadvertently helped the Bald Eagle in some places. The Osprey is an expert at fishing, being one of the few birds to actually plunge into the water to grab a fish, and it is more proficient at catching fish than the eagle. The larger, more dominant Bald Eagle often will watch for an Osprey to catch a fish, then chase and harass the Osprey until it releases the prey, which the eagle snatches away and eats.

General population

The Bald Eagle presumably had stable, if not growing populations before European settlement. It is estimated that there may have been 500,000 Bald Eagles in the continental United States at that time. Back then, American Indians would have killed some eagles for feathers, but this activity obviously would not have impacted the overall population. One thing is sure—most American Indians revered the Bald Eagle and honored the ideals it represented, so it wouldn't be far-fetched to say that the decline of Bald Eagle populations didn't start until after European settlement. In fact, eagles were oftentimes shot by settlers who considered the bird competition for precious food. Other pioneers shot eagles, believing them to be bloodthirsty killers of other wildlife. Of course, this notion was unequivocally not true. Bald Eagles, such as these adults and juvenile, kill only to eat.

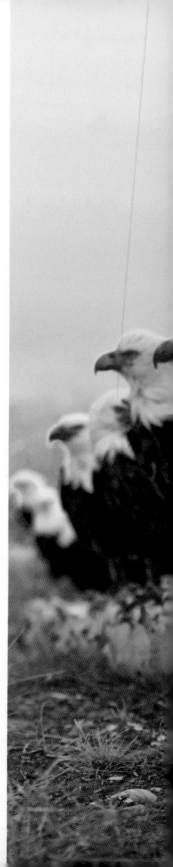

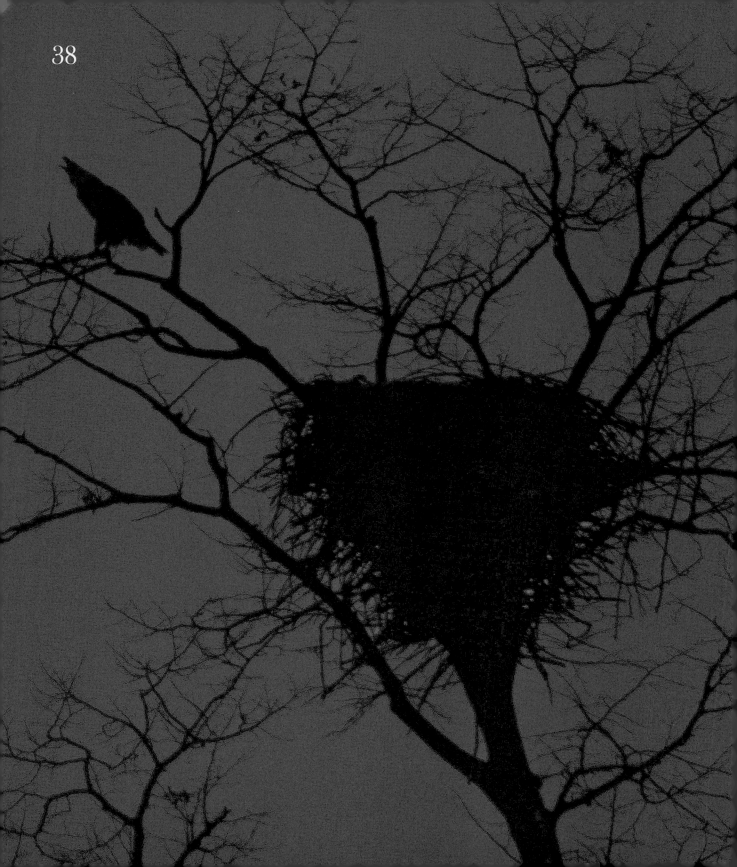

The decline of the eagle

It is estimated that when the Bald Eagle was adopted as our national symbol in 1782, there were only about 100,000 nesting pairs and reports had already been made of its decline. Many factors have taken a toll on the populations of this magnificent bird of prey—indiscriminate shooting, prejudice, poison baits for killing coyotes and wolves, government bounties, systematic use of the pesticide DDT and dumping of other toxic chemicals, habitat destruction, overfishing (which reduced a significant food source) and lack of education about the eagle's role in the environment.

DDT and eggshell thinning

Populations steadily declined until the 1940s, when the first attempts to help the plight of the eagle were made. The Bald and Golden Eagle Protection Act, passed in 1940, provided some protection and gave a glimmer of hope that the eagle would make a return. This bright spot quickly dimmed, however, when it was discovered the effects of DDT were having on Bald Eagles, Common Loons and many other large predatory birds. DDT had been heralded as a miracle chemical for its effective control of insects. What was not understood at the time was that DDT built up (bioaccumulated) in other animals, especially birds.

This is how it worked—DDT was sprayed liberally to control insects. The insects were contaminated, and then eaten by fish. A fish might eat hundreds of insects, all of which had trace amounts of pesticide. As the fish ate more contaminated insects, the amount of DDT increased in its own body. Now enter the Bald Eagle. A large portion of its diet is fish, and most fish had small amounts of pesticide. With each fish it ate, an eagle consumed more and more contaminant, resulting in a large dose of DDT delivered into the eagle's system (DDT bioaccumulation).

The pesticide didn't produce external symptoms in adult birds, but it greatly impacted the reproductive system. DDT bioaccumulation caused Bald Eagle eggshells to become thin and fragile—so much so that the weight of incubating adults was causing the shells to break and developing chicks were being killed. Since eagles can live 20 years or more in the wild, the effects of diminished reproduction went unnoticed until after the contaminated adult birds started dying of natural causes. The lack of a younger generation of eagles replacing the aged and dying eagles pointed to the painfully obvious effects of DDT. By then it was nearly too late to save the species.

Eagles had been eliminated from many regions and were barely holding onto others. By the early 1960s, the population of eagles hit its all-time low due to DDT bioaccumulation, with an estimated population of just over 400 nesting pairs in the Lower 48 states. At this time Alaska and Canada had relatively robust populations, but these were also impacted and declining. In addition, Bald Eagles in Alaska were being killed by fishermen who thought they were protecting salmon, resulting in a reduction of at least 100,000 more eagles over the past century.

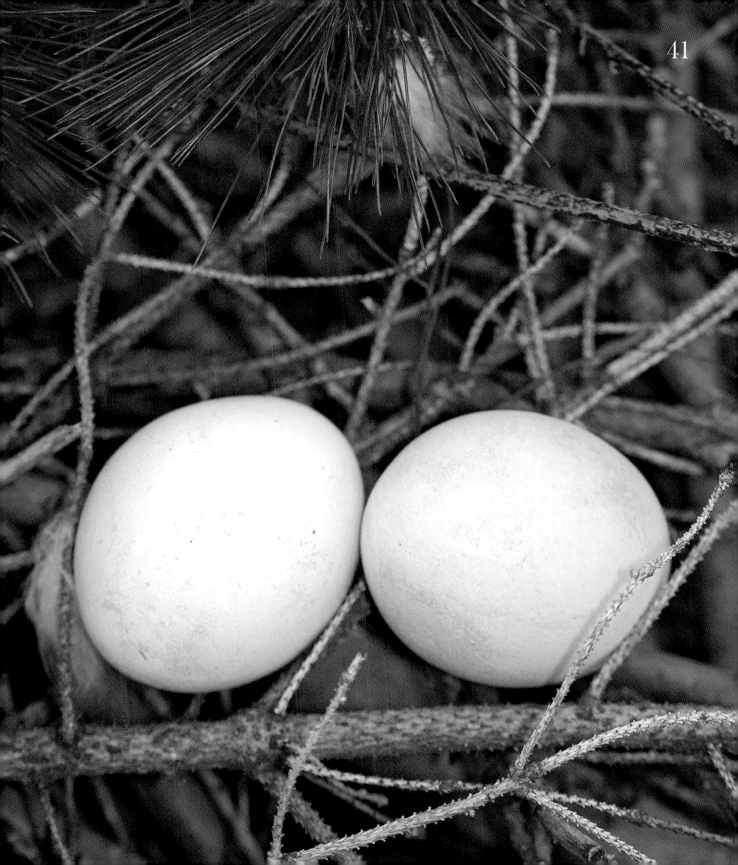

The recovery of the eagle

The 1970s were the turning point in the recovery of the Bald Eagle. Two significant issues came to fruition during this decade. The first was the banning of DDT in the United States in 1972. It would take many years for the effects of the pesticide to flush through the natural cycles, but we were well on the road to recovery. The second and, some say, just as important, was the passing of the Endangered Species Act in 1973. This landmark legislation protected the Bald Eagle and many other species in peril. It provided special protection with consequences for violators of the law.

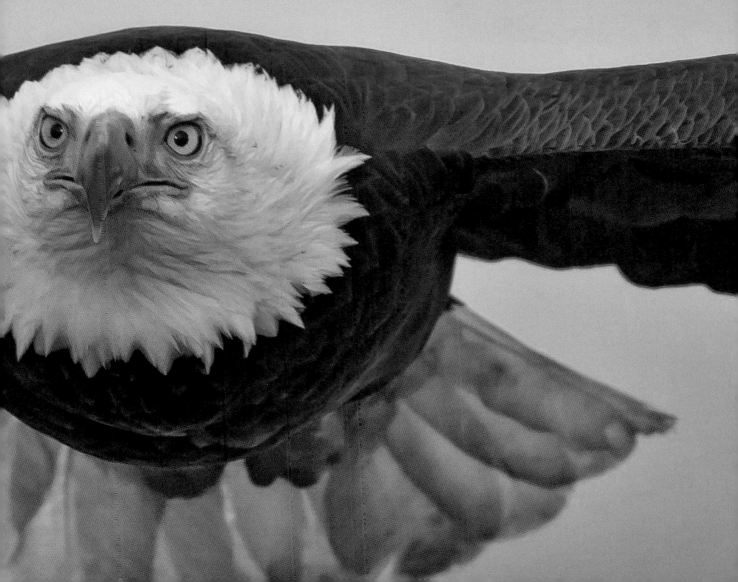

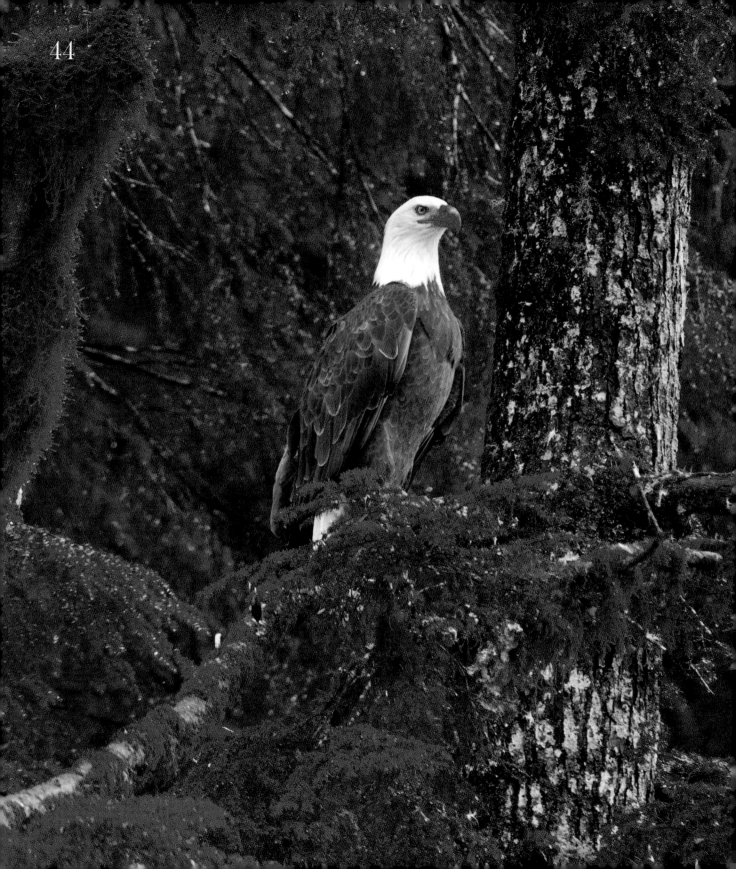

Habitat and education

In addition to these two major events, something less tangible had been occurring. The 1960–70s birthed a widespread environmental movement that, to a certain extent, continues today. A key component of the movement was environmental education. Providing accurate information about every part of our environment, habitats and their vital interrelationships became the staple for schools and nature centers across the country. The children of our nation started to learn for the first time about the value of a thriving environment, the importance of keeping every species from tiny insects to large furry animals healthy, and how crucial the habitat is to all species including humans. Most importantly, our children began to learn that the natural world is interconnected in a large web of life, that if one part of the environment is changed, the effects will be felt across the entire ecosystem.

Federal and state agencies were more focused at that time on providing hunting and fishing opportunities, but they also started devoting additional effort and money to nongame species. Over the following decades this trend continued. A healthy environment for nongame species also means a healthy one for game species. Today we regard the Bald Eagle and other nongame species as an essential component of a healthy, well-balanced and flourishing environment.

The future of eagles

It wasn't until 1963 that we started to get accurate data on the population status of the Bald Eagle in the Lower 48 states. This data, collected by the U.S. Fish & Wildlife Service, was used to document the recovery of the Bald Eagle over the ensuing decades. Brought from near extinction with 400 nesting pairs of eagles, the numbers slowly increased to 417 nesting pairs during 1963, the first year of census. The next census in 1974 recorded 791 nesting pairs. Another decade later, the 1984 census counted 1,757 nesting pairs, and 1994 showed a significant increase, with 4,449 nesting pairs. The latest data found 8,000 nesting pairs of eagles in 2005.

On August 11, 1995, the Bald Eagle was reclassified by the U.S. Fish & Wildlife Service, going from endangered to threatened in the Lower 48 states. In August of 2007 the Bald Eagle was removed from the list but remained on several of the local state endangered species lists. By the mid 2010's our National Symbol had populations strong enough to be delisted from most of the individual state lists.

The eagle is also under the protection of the Bald and Golden Eagle Protection Act and the Migratory Bird Treaty Act. Thanks to the many efforts of federal, state and private environmental organizations along with countless volunteers, the Bald Eagle is now nesting in nearly every state in the nation. If we continue to avoid our mistakes of the past, it is possible for the future of the eagle to remain as high as it desires to fly.

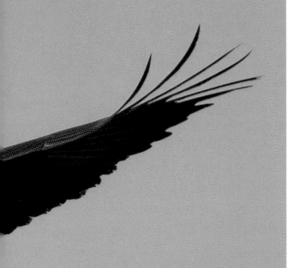

Differences of the sexes

The adult Bald Eagle is visually striking, with a pattern of colors that gives it a majestic or stately look. Its bright white head and tail contrast boldly with the dark body and wings, which range from deep brown to nearly black. Complimenting this are intense yellow eyes, a large down-curved yellow bill and bright yellow legs and feet.

Adult Bald Eagles are nonsexually diachromatic. This simply means that both sexes have identical plumage and look the same. This is common in jays, sparrows, crows and many other bird species along with most birds of prey such as hawks, owls and eagles.

Impressive size

There is one visible sexual dimorphic difference, however, between adult male and female eagles—size. It is the female eagle, not the male, that is the larger of the two. In fact, an adult female Bald Eagle is usually about 10-20 percent larger, measuring 35-38 inches in length from the top of the head to the tip of the tail. Adult males are 30-35 inches. The wingspan of the female eagle is also proportionally larger, ranging from 80-90 inches compared with the male wingspan of 75-85 inches.

Adult female eagles weigh up to 14 pounds. Males are usually closer to 10 pounds. Eagles look like huge birds, but most of the bulk is actually just feathers. An average adult eagle has a little over 7,000 feathers, each one hollow and lightweight. If all of the feathers were removed from an adult and weighed, the feather weight would be just over 1 pound, about 7-10 percent of the total weight of the bird.

Size by region

Eagles living in northern states and Canada are larger than their cousins in southern states such as Florida, Texas and Arizona. Northern eagles can be up to 7 inches taller than southern eagles of the same sex, with male northern eagles growing slightly larger than female southern eagles. This size difference is a well-documented natural phenomenon called Bergmann's Rule; generally speaking, animals or birds of the same species are larger the further north they are found. Smaller or thinner animals radiate more heat than larger animals, so a larger body enables an eagle to stay warm in cold weather. Bergmann's rule also applies to other animals, such as White-tailed Deer and Black Bear.

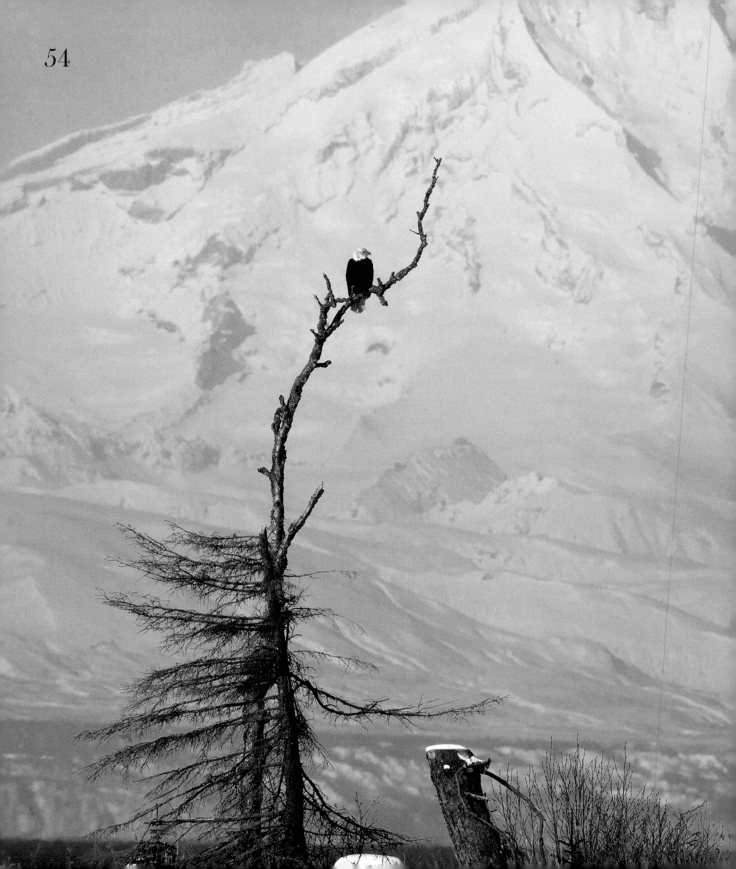

Life span

The Bald Eagle not only has an impressive size, it also has a remarkable life span. The rigors of living in the wild often take eagles well before their prime—in fact, most eagles die in their first year of life. However, once young eagles pass their first-year milestone, their chances for survival increase dramatically. On average, eagles live about 15-20 years, with some reaching 30 years of age or more. Captive eagles with a constant food supply and medical care can live much longer, some to almost 50 years.

Extraordinary feathers

Feathers are truly an engineering marvel! An average adult eagle has just over 7,000 feathers, each hollow, lightweight and flexible, yet extremely strong. Feathers are of utmost importance to all species of birds, making it possible for them to keep warm, cool off, fly, attract a mate and more.

Feathers are the essence of a bird. The most important function is protection of the body from cold and excess heat, accomplished by trapping warm or cool air within layers of feathers. Feathers work in the same way that a quilt keeps you warm—warm air is retained beneath the covering. All a bird needs to do to regulate heat and stay comfortable is change the position of its feathers, either to trap more air to warm up or release warmed air to cool down. Feathers also provide excellent waterproofing, as well as protection from branches and other obstacles the bird may encounter while out and about.

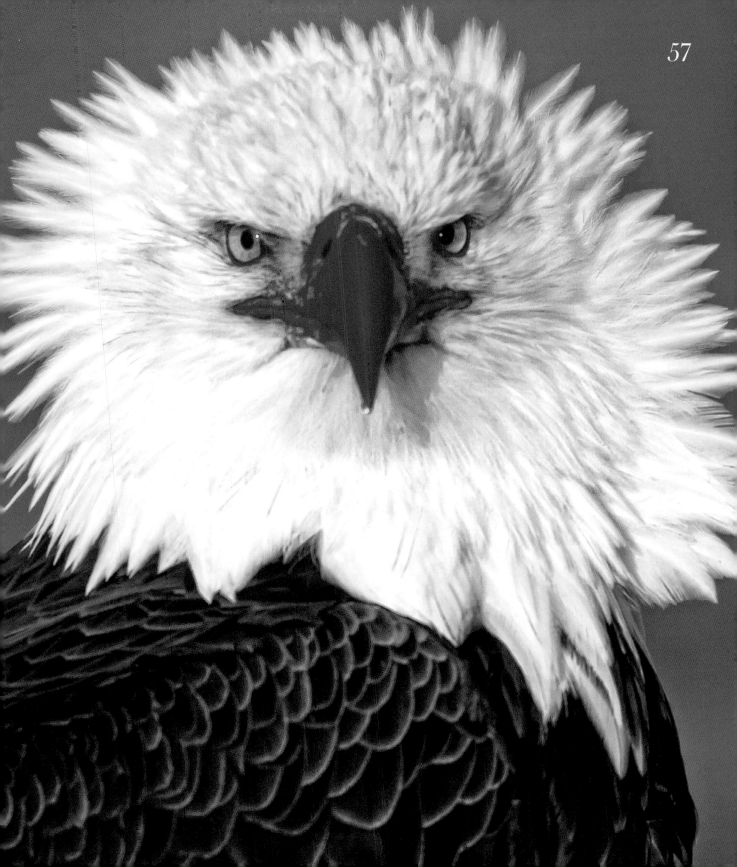

Feathers in layers

Feathers are positioned to overlap each other and form a dense layer of protection or covering. There are, in fact, several layers of feathers. The outer feathers are mainly contour feathers—the feathers you see when you look at a bird. These feathers have a central shaft (rachis) that curves to match the body contours. They tend to be wider than the other feathers and are fairly long with a blunt, rounded tip. Underneath the outer layer is an inner layer of smaller feathers called down feathers. Down feathers are usually off-white or gray and short, round and fuzzy. These are extremely important feathers, serving to insulate the body.

The wings and tail have another type of feather. The central shaft of wing feathers is often offset to one side or the other, with the curve relative to the left or right wing. These feathers, usually long, narrow and with a pointed tip, are key to identifying the color and shape of a bird.

Interlocking feathers

Of equal importance to distinct feather types is the amazing fact that feathers interlock. Recent research in ducks and geese shows that it is not the oil gland that waterproofs—it is the interlocking ability of feathers that makes water run off without soaking in and chilling the body. Oil production keeps feathers soft and flexible, which in turn increases their useful life and ultimately enhances their waterproofing ability.

The many marvels of feathers enable eagles to live in extremely cold environments and warm climates. Eagles will migrate from cold, snowy northern states during winter only due to lack of food, not because of any inadequacy of their feathers to keep them warm.

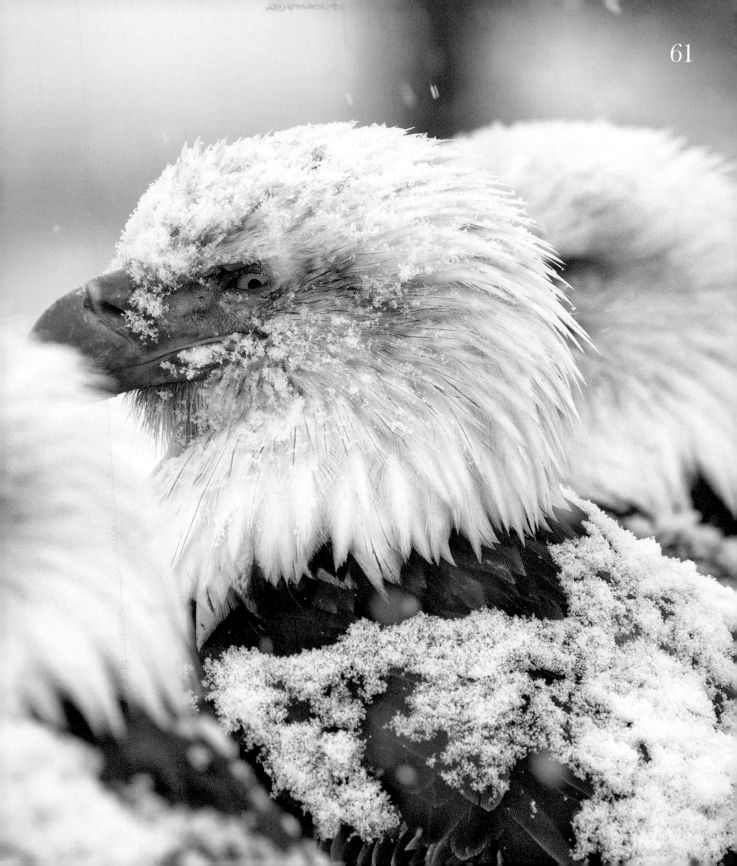

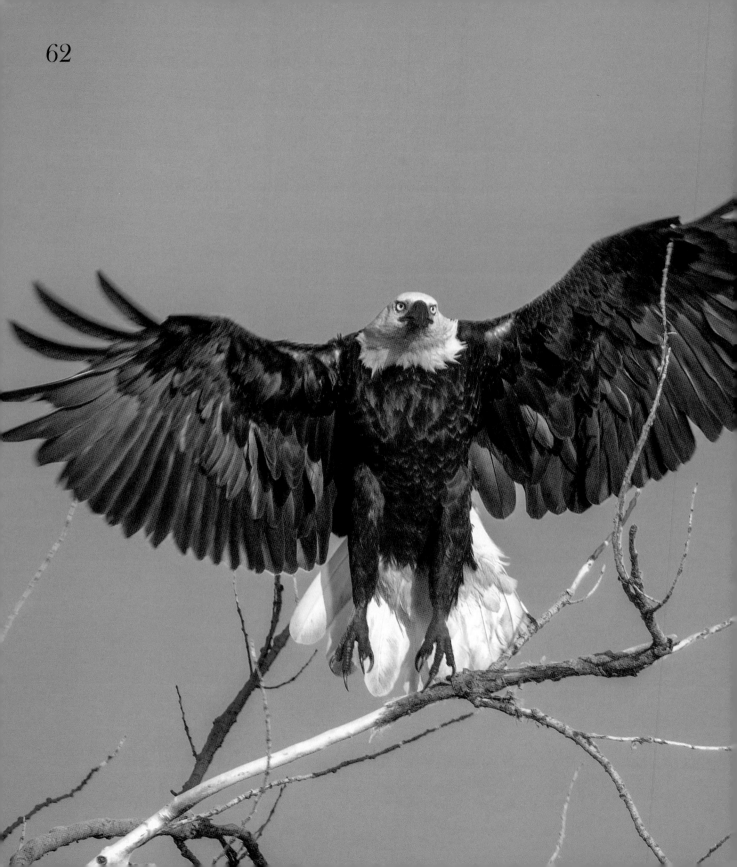

Growing into feathers

Just after hatching, eagle chicks are covered with tiny down feathers that range in color from dull white to gray. These are the same type of fine feathers usually found beneath the outer feathers of older birds. Young birds quickly grow a coat of dark outer feathers, which covers the down. This first coat of outer feathers is not molted until after the bird has reached 1 year of age. Over the next 4–5 years, there is a considerable variation in plumage color and pattern.

Some young birds, known as subadults, are very dark. Others are extremely light. A young eagle has a dark bill and, at the base, a dark patch of skin called a cere. As the young eagle ages, the bill and cere turn dirty yellow. A 2-year-old bird may have a dark bill or a dull yellow bill unlike an adult bird 5 years and older, which has a bright yellow bill and cere. Young eagles start out with gray-to-brown eyes, but these turn yellow when the birds reach sexual maturity.

Typical adult plumage—white head and tail with a dark body—is usually acquired at 5-6 years of age. Some birds obtain their adult plumage earlier, at 4 years of age. Others retain some of the darker head feathers until they are 8 years old. In any case, once an eagle molts to adult plumage, the coloration stays that way for the rest of its life.

Juvenile plumage

Juvenile Bald Eagles that are 1–4 years of age don't look like their parents. They have similar brown, black and white colors (as shown), but their plumage lacks the precise pattern of the adults'. At the juvenile stage of life, the birds look so different from the adults that it often causes them to be confused with other eagle species such as the Golden Eagle.

In addition, the primary flight feathers and tail feathers of juvenile eagles are up to several inches longer than those of the adults, making juveniles appear noticeably larger than their parents. The longer feathers provide more surface area, which presumably helps the young while they learn to fly.

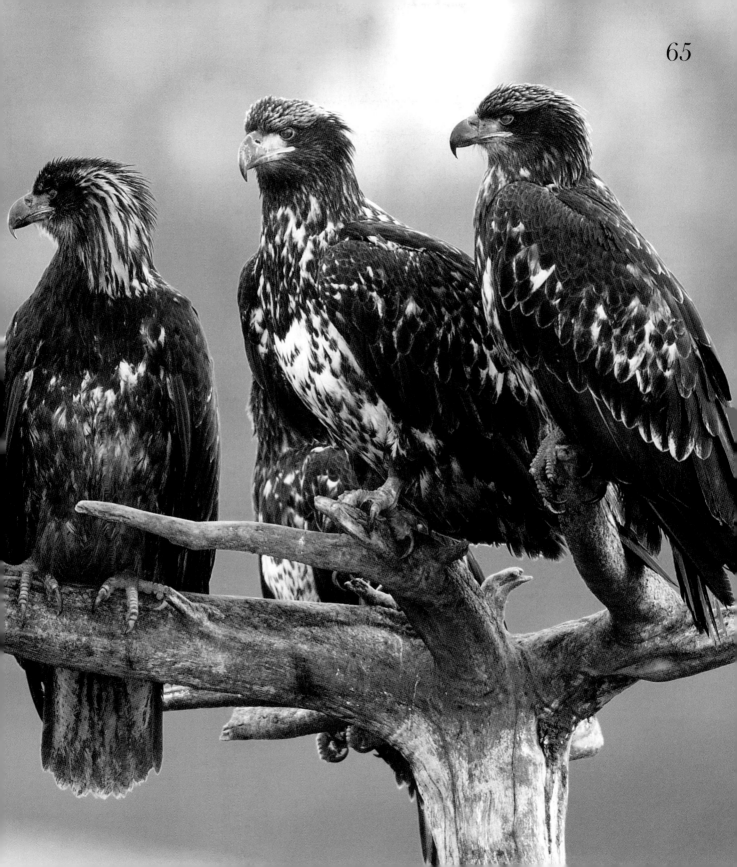

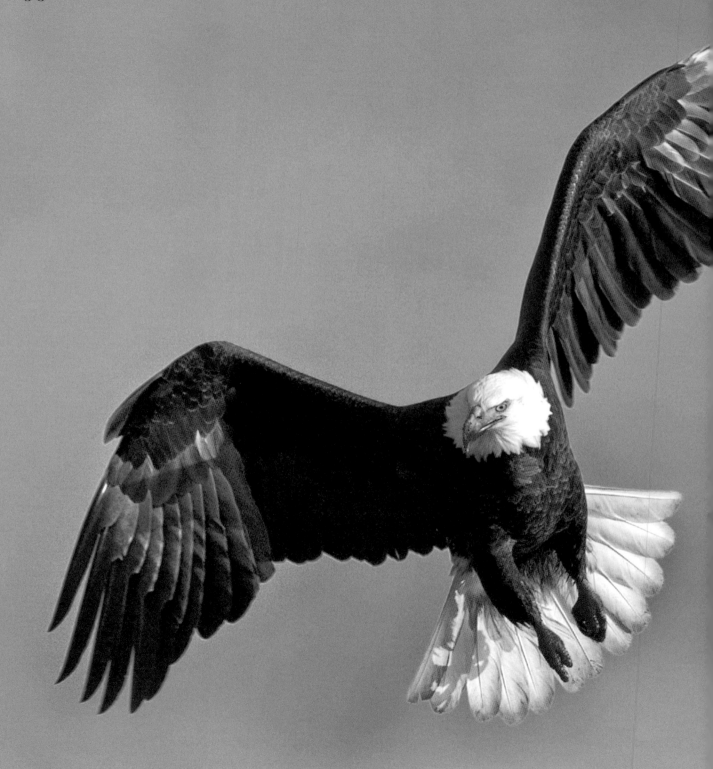

From dull to spectacular

Molting—the shedding of old feathers followed by the growth of new—is based on latitude, diet and other factors. Eagles in Canada being molting in March or April, while eagles in Florida start their molt in November. Eagles between Canada and Florida molt at various times from April to November. The annual molt for eagles is an incomplete feather replacement, which means most body feathers are replaced along with some wing feathers, but not the larger flight feathers. Nearly all tail feathers are replaced, although not usually all at the same time.

The large flight feathers in the wings are replaced slowly over time, only a few at a time and often in pairs, one from the same position on each wing. If all or nearly all flight feathers were replaced simultaneously, the bird would be rendered flightless and vulnerable since it would not be able to hunt for food or defend itself.

Preened and clean

A typical adult Bald Eagle has more than 7,000 feathers. Caring for the feathers, known as preening, is extremely important because it is essential for the health and survival of the bird. Preening also helps to reveal the color patterns of the bird. Bald Eagles spend a lot of time preening—the process of running the bill through feathers to remove dirt and small particles of debris, and straightening bent feathers. Preening also involves sunning and water bathing. Bald Eagles do it all to keep their many feathers in top shape.

An eagle begins to preen by fluffing its feathers on one part of its body. Grasping a feather near the base, the bird will nibble along the shaft toward the tip. This meticulous action moves oil and dirt that has accumulated to the tip, where it falls away. After cleaning a feather in this fashion a few times, the eagle may draw the feather up through its bill without nibbling, which smooths the feather and restores the original streamlined shape.

An eagle preens the feathers on its head (and other feathers that cannot be reached with the bill) by scratching them with its feet. To clean the head feathers, the eagle will turn its head to the side, raise a foot and, like a dog with an itch, move it quickly back and forth over the feathers in a typical scratching motion.

Preening is often triggered by a tickle or other stimulus such as an insect. However, preening is not simply a nervous system response. Studies show that birds also preen without a stimulus, showing it to be a voluntary maintenance activity for good health.

Bald Eagles increase preening during molting. Eagles that spend more time in the nest to incubate eggs or brood young also preen more than usual. For several reasons, preening is more common during warm weather than cold. Insects and mites that bother eagles during summer are unlikely to be active in winter, and during short winter days, eagles spend their time feeding, leaving less time to preen.

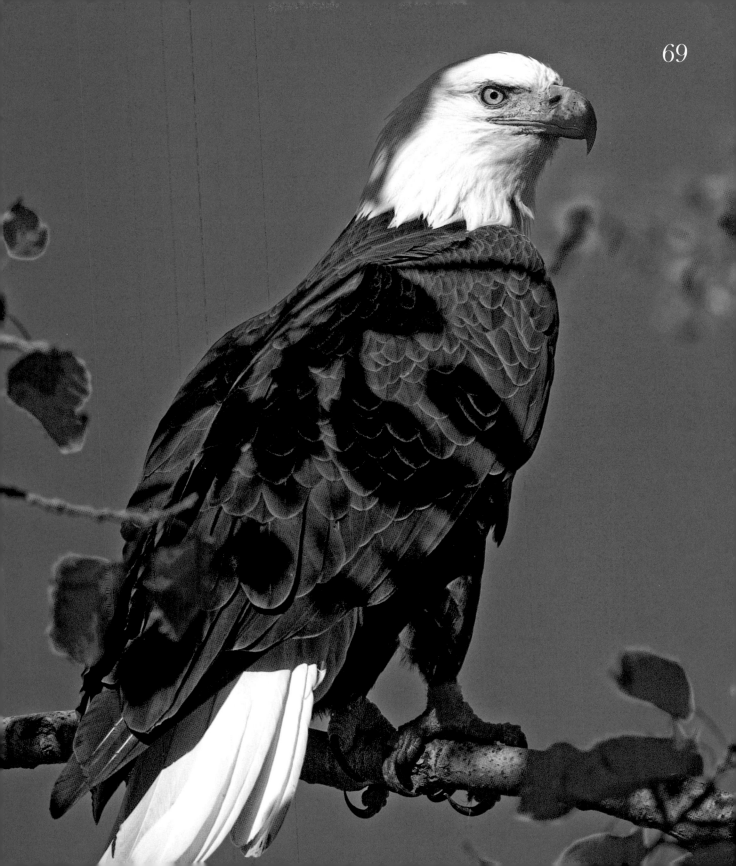

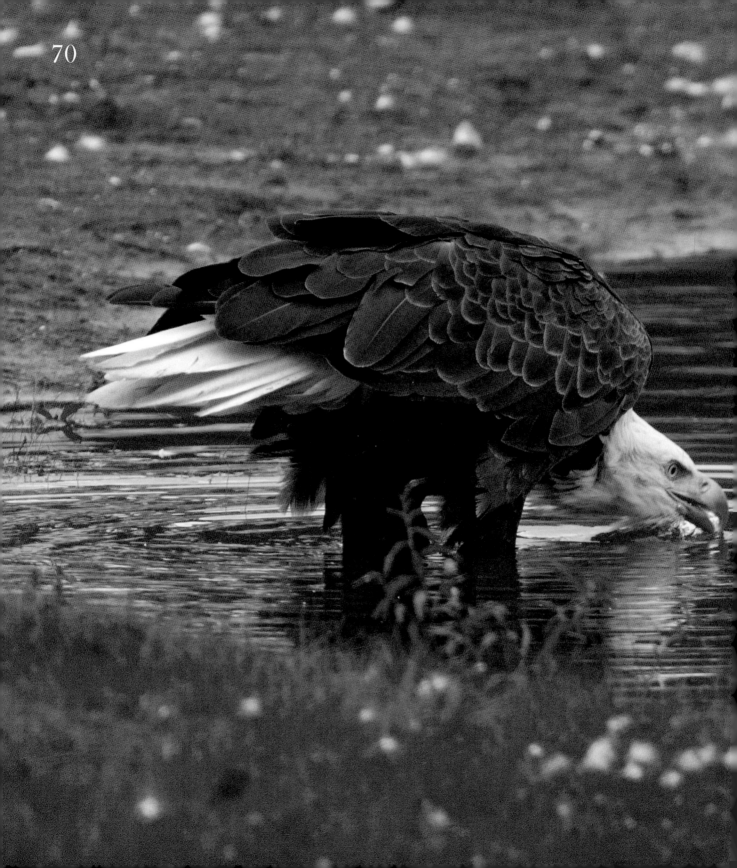

Bathing

Bathing is another part of preening. An eagle will usually land at the edge of a lake or river and walk slowly into a shallow area about 2 inches deep. After looking around the site for a while, perhaps to ensure there is no danger, the eagle begins to bathe. This often starts with the head, which the eagle dunks repeatedly until it is fairly wet. Afterward, the bird concentrates on the rest of its body. When satisfied with the bath, the eagle returns to dry land, where it shakes off the extra water and flies to a branch to clean and straighten out its feathers.

Sunning

Another way for eagles to maintain good feather health is by sunning. Sunning heats the feathers and keeps them supple. While perched on a branch in direct sunlight, an eagle will assume unusual postures, often fluffing its feathers while dropping the wings and spreading its tail. Different positions presumably allow sunlight to reach parts of the body that normally are not exposed. Sunning uncovers insects and mites, which don't like the additional heat or light, and most likely causes them to leave. It is possible that sunning is pleasant for the eagle in much the same way that it feels good for us to lie in warm sunlight.

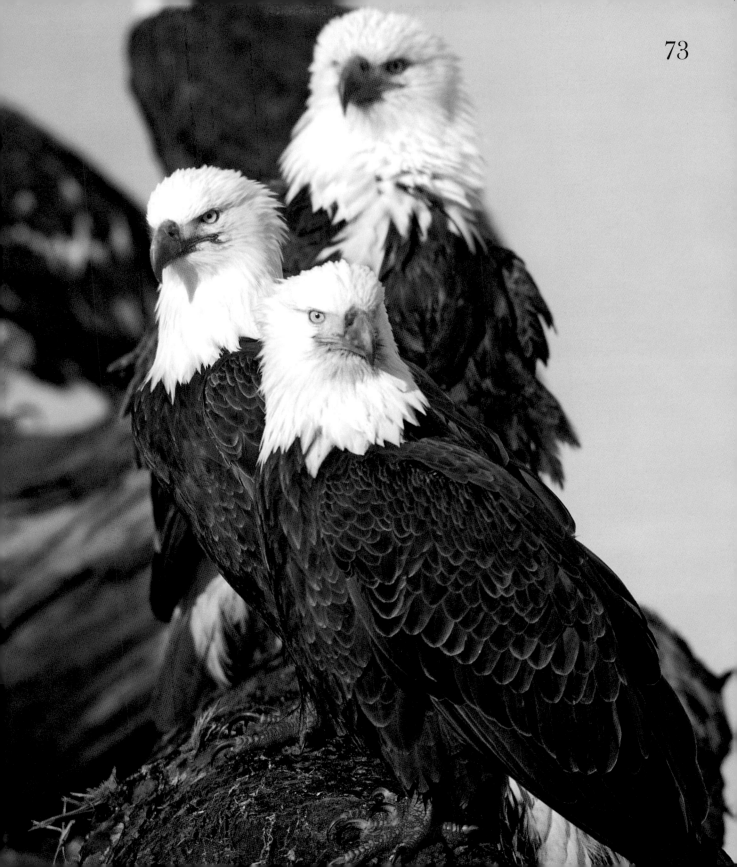

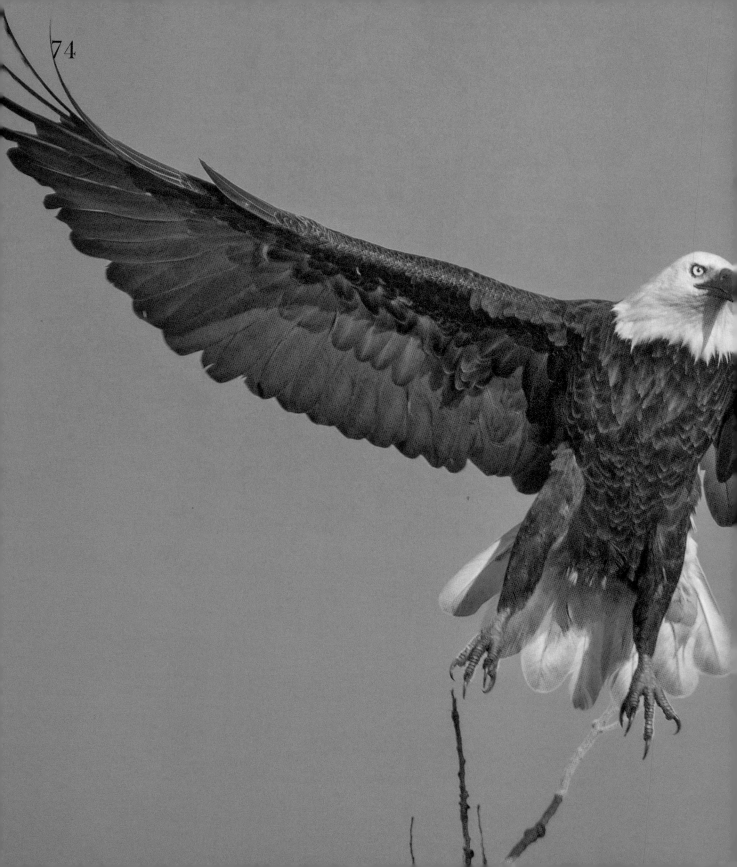

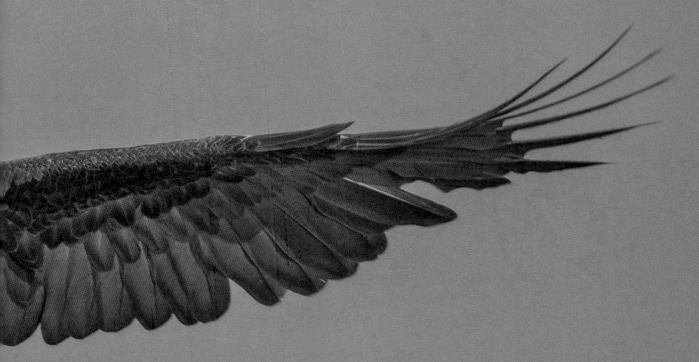

Wings to soar

Like other birds, eagles have 10 primary flight feathers—the longest feathers at the tip of the wings—and 17 secondary feathers, making a total of 4 more total flight feathers than other raptors. These extra feathers create more surface area with larger wingspans up to 7 feet from wing tip to wing tip, which helps during soaring.

During flight, an eagle's wings appear long and broad. Feathers at the farthest end of the wing (wing tip) are widely separated and the individual flight feathers stretch out like spread fingers. Many people think these characteristics help identify a soaring eagle, but if an eagle is flying into a strong headwind or is in a rapid descent, the wing tip fanning collapses and the individual flight feathers won't show. Thus, these features do not help to correctly identify an eagle.

Flapping and takeoff

An eagle's wing flaps are strong, efficient and easily lift the bird from land or water. Eagles take flight from a standing position with only 1–2 flaps and fly off the water's surface with 1–2 more powerful flaps.

Sometimes an eagle will miss its target fish or miscalculate the angle of attack and end up in a lake. Not to worry—the eagle's hollow feathers function like a built-in life jacket and prevent the bird from sinking. I've watched eagles float on the surface for up to 10 minutes before taking flight. Rumors about eagles drowning after landing on the water are just untrue. If too soaked to fly, they simply swim to shore.

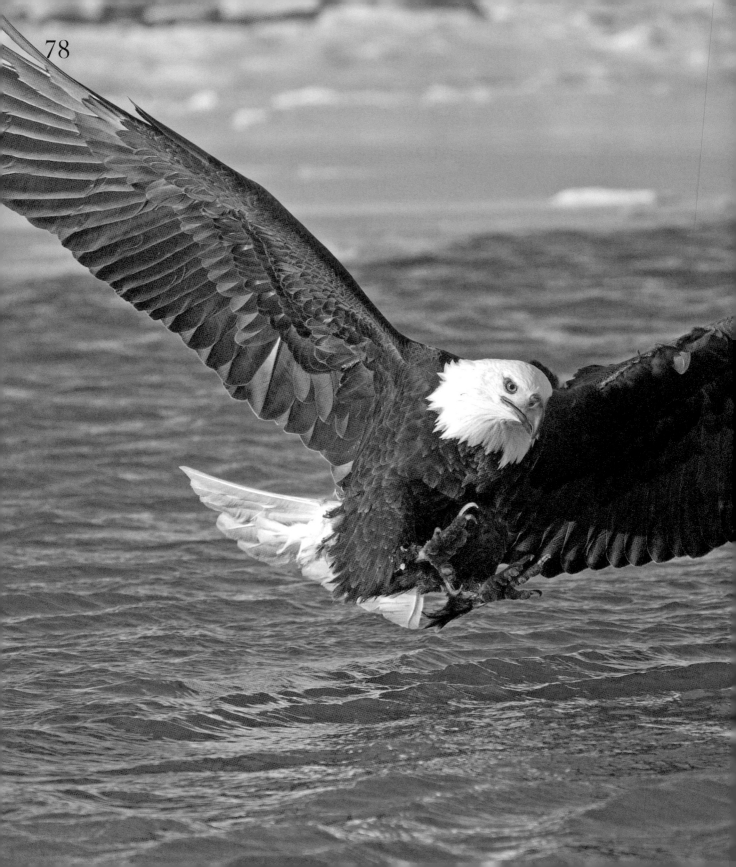

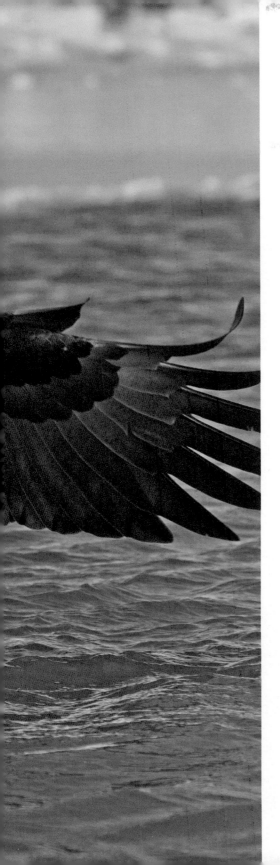

Flight maneuvers

The tail of the Bald Eagle is an important device for flight, used for maneuvering and slowing down. While gliding on thermals, tail feathers can be spread out, which increases the eagle's surface area, and acting like an extra wing, helps to carry the bird higher. Altering the angle of the tail feathers helps an eagle slow down or "apply the brakes" when landing. Muscle movement in the rump pulls the tail feathers down to be perpendicular to the bird's body, slowing flight. Combination changes in tail feather position and angle make it possible for minor adjustments to be made during flight.

Bald Eagles can fly very low over water and also to incredible heights—with some flying at altitudes as high as 10,000 feet! They usually travel at average speeds of 30-35 mph, with much faster flying occurring during courtship flights and while diving down from heights for fish.

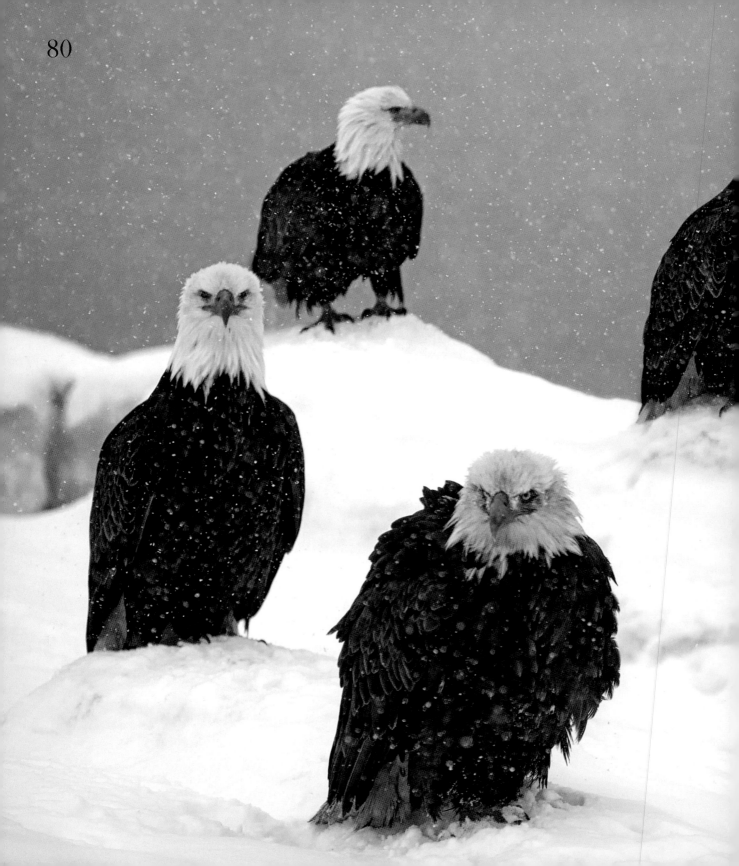

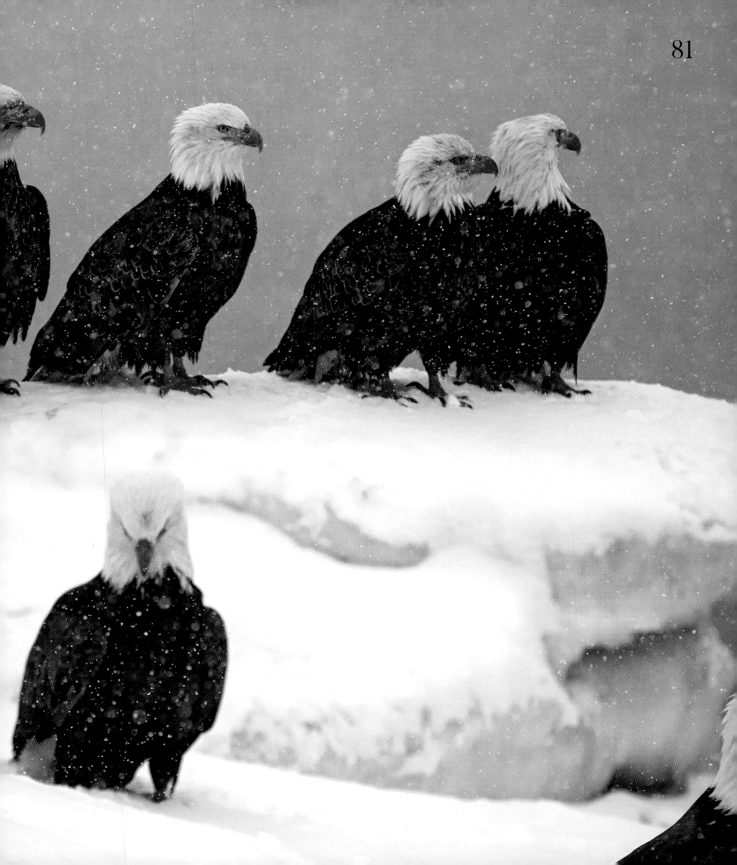

Soaring on thermals

Only large birds with large wings can soar, and Bald Eagles are excellent at it! The process of soaring involves flying without flapping. Eagles do this by finding thermals to ride. Thermals are columns of warm air rising into the sky. An eagle uses thermals like escalators to gain altitude, gliding from one to another, drifting higher and higher. When there are enough thermals, an eagle does not need to flap. This conserves energy and keeps the bird from overheating.

Sometimes landforms such as ridges and valleys produce updrafts of air that act like thermals. Eagles locate these updrafts and use them to their advantage. Soaring works well to save energy during long-distance migration. Several eagles can use one thermal or updraft at the same time and also share it with other birds of prey such as hawks. A group soaring together on a thermal is called a kettle.

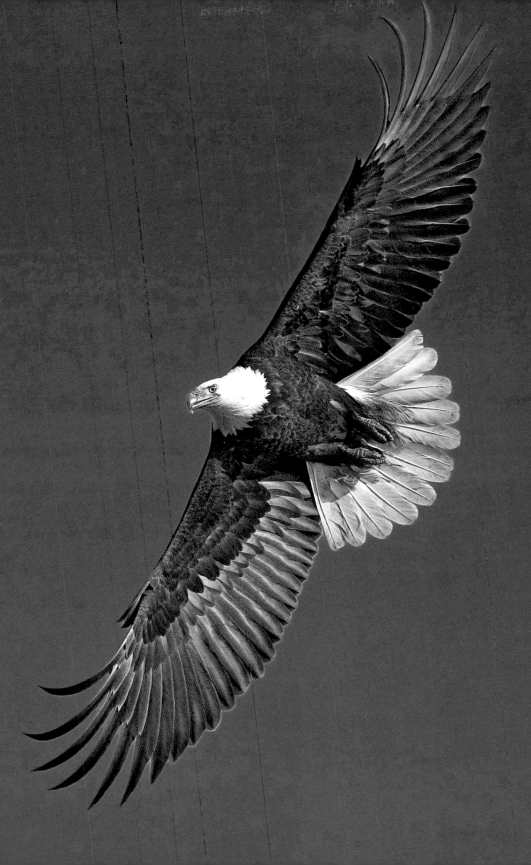

Hollow bones

Like those of other birds, a Bald Eagle's bones are hollow, making them lightweight, yet strong. Being light in weight is important in birds, especially when it comes to flying. The lighter the bird, the less energy it takes to propel itself through the air. The bones of an adult eagle weigh about 8 ounces altogether, only 5–6 percent of its total body weight. The dense bones of a human adult are much heavier and account for approximately 20 percent of human weight.

Studies show that adult female eagles have many spurs or spoke-like structures within their hollow bones from which they draw extra calcium, which is needed for eggshell production. Some eagle species eat the broken eggshells after their chicks hatch, replenishing the calcium supply.

Impressive bill

The bill or beak (also known as the rostrum) is an extremely important structure that serves as the mouth. It is used for a variety of functions such as eating, tearing food, grooming, rearranging feathers, manipulating objects and courtship. Both terms are synonymous, but "bill" tends to be used more properly by ornithologists; "beak" is the usual preference of the general public.

A bird's bill is so important that most species are classified by its type or shape. The shape is directly related to the kind of food a bird eats. A hummingbird's long, thin bill, for example, is perfect for inserting deep into a tubular flower to sip nectar. The thick, strong bill of a cardinal, on the other hand, is ideal for cracking or crushing the tough shells of seeds.

A bill has an upper jaw (maxilla) and lower jaw (mandible). There are no teeth. Jaws are strong, made of a lightweight bony material, and hollow, conserving even more weight. The outside of the bill, called the rhamphotheca, is covered with a thin sheath of keratin—the same tough material found in hair and fingernails. Keratin is thicker in bills than in fingernails and is constantly growing. Without wearing down or trimming, a bill will become too large. The bill of an eagle regenerates from the inside toward the outside and the edges wear away slowly whenever the jaws contact, including during feeding and grooming. Injured birds in captivity are less active and need their bills trimmed artificially.

Underneath the outer layer of the bill and above the bony base structure is a layer that has many blood vessels and nerve endings. This makes the bill a living part of a bird's anatomy, not just a dead, sharp object on its face.

In eagles and many other birds is a fleshy structure at the base of the bill called a cere. This is a leathery skin, often bright yellow, that extends across the base of the upper bill. The cere presumably protects the nostril openings, but there is not much agreement as to its function.

Just as the bill of a hummingbird is ideal for sipping nectar and the cardinal's bill is well suited for cracking seeds, the eagle's bill is exactly right for a carnivorous bird of prey. The upper bill is sharply hooked and perfect for tearing into fish flesh, which is the eagle's main diet. In addition, the edges of the bill are sharp enough to slice through even the toughest hides of roadkill deer and other unfortunate animals.

An eagle's upper bill overlaps the lower bill, creating a scissor-like cutting effect when the bird closes its jaws together. Eagles don't have teeth or mash food—they just tear meals apart with their fierce bill, swallowing each bite whole.

Weak sense of smell

Located on the upper bill near the base and cere are two large nostril holes called nares. Nares function in much the same way as a nose. Air passes through the nares and travels through the respiratory system until it reaches the lungs.

Nares in eagles are large, but the birds still don't have a good sense of smell. This is not critical since eagles hunt exclusively by eyesight. Smell plays no part in food gathering.

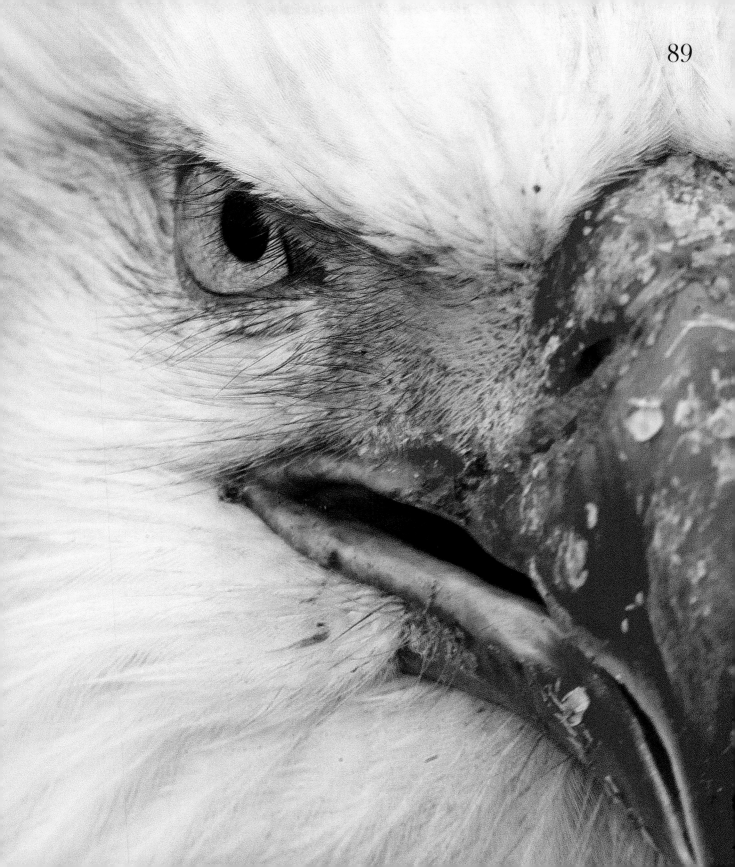

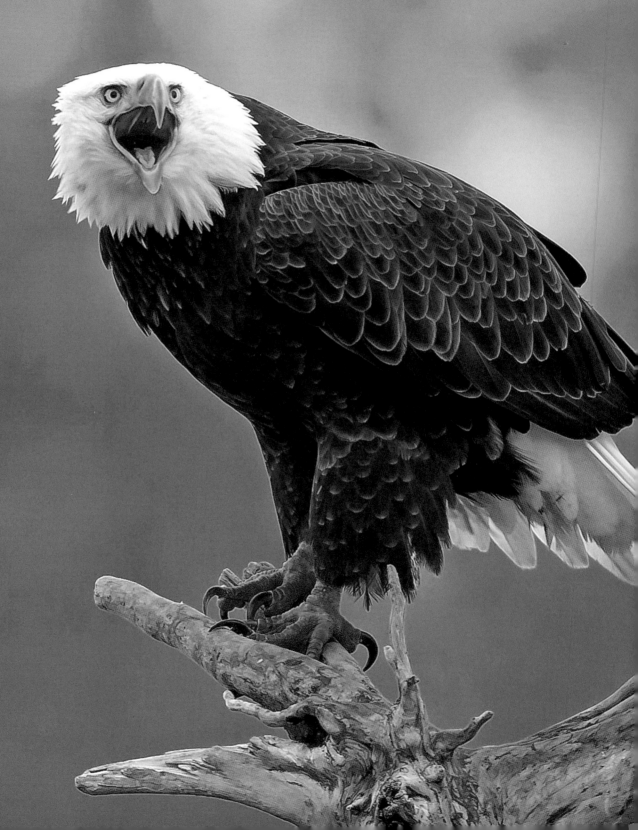

Stationary eyes

Eagles have some of the largest eyes in the bird world. Eagle eyes are much larger than human eyes when compared to the size of their heads and weigh nearly as much as the bird's brain. The eyes may appear small next to the size of the bill, but most of the eyes are concealed in the skull. The eyes require so much space in the skull that they stay mainly stationary in the sockets. Unlike humans and other mammals that can move their eyes in sockets to look from side to side, an eagle has to move its entire head to see objects outside of the range of vision.

Excellent sight in 3D

With eyes positioned in the front of its face, an eagle is able to have good three-dimensional (stereoscopic) vision, which is the same as binocular vision with good depth perception. This is important for judging distance when the bird is hunting for food.

Unlike songbirds, which have one focus spot within each eye, eagles have two focusing points. In the back of each eye is a region called the central fovea, where the majority of light-sensing cones (photoreceptors) are concentrated. These cones produce the sharpest one-eyed (monocular) vision and make the eagle's sight very good at the ten and two o'clock positions, just off to the sides of the bird.

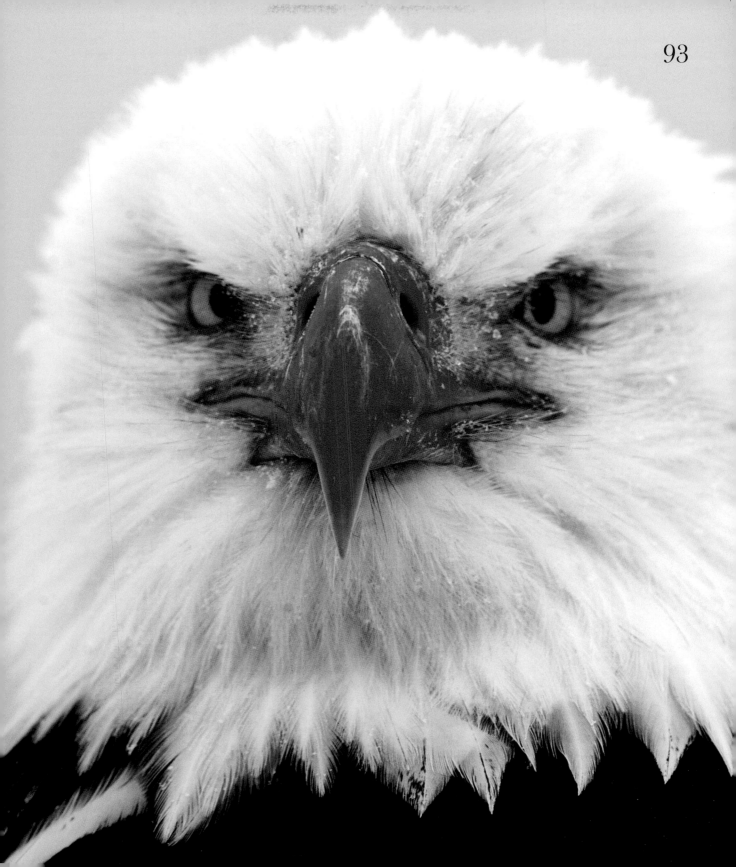

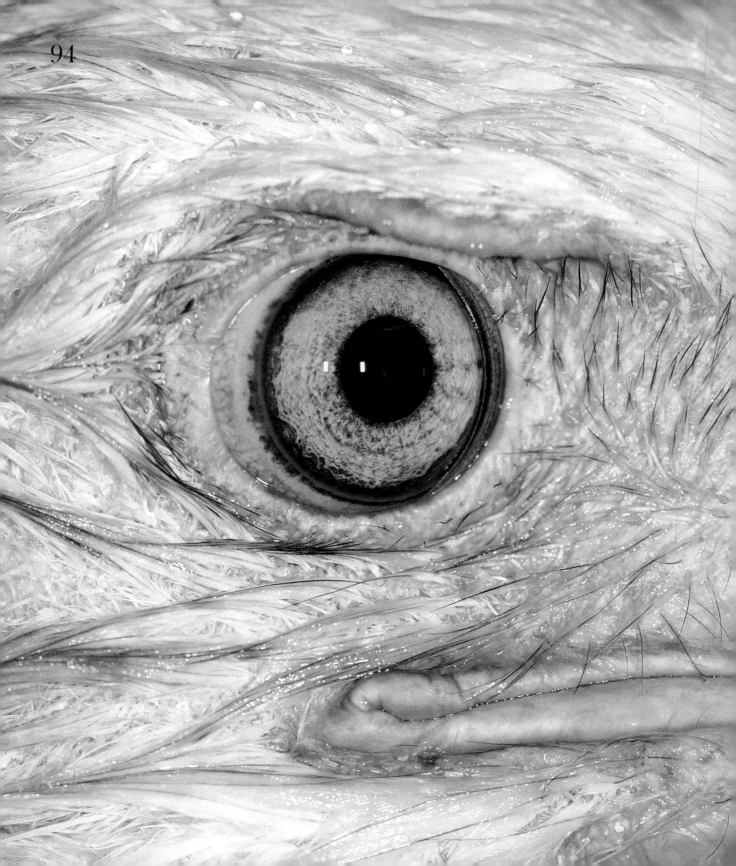

Binocular vision

Eagles have a second focus spot in their eyes called the temporal fovea. This region also has high concentrations of cones, but is located in the corners of the eyes and allows for extremely sharp vision directly in front of the bird. These cones are responsible for binocular sight, which requires the use of both eyes together to see something clearly. Altogether, an eagle enjoys three well-focused views—two side views and one forward view—all at once. This presumably allows the eagle to track prey and also avoid crashing into objects.

Cones are responsible for visual acuity and make color vision possible. The more cones, the better the vision. Eagles have five times more cones than people—up to 650 million cone cells per square inch. Eagles see colors very well.

Like most birds, eagles have another set of eyelids known as a nictitating membrane (as shown) that keeps the eyes clean and moist. Eagles blink these membranes so quickly, it is only with the aid of a camera lens that we can see them in action.

Eagles and other birds of prey have specialized oil droplets that may function as light filters, working in much the same way as polarized sunglasses. This would be greatly beneficial to an eagle during a midday hunt, when sunlight shines brightly over the reflective surface of water. In reducing glare, it could even help the bird to see fish.

Eagle eyes

Eagle eyes have a unique tubular shape, which helps increase visual acuity. Changes to the curvature of the lens (which is in front of the retina) allow images at varying distances to be seen sharply. The lens of the eye is responsible for focusing and is comparable to the lens of a camera. Muscles in each eye exert pressure on the lens to flatten it, enabling sharper focus on objects farther away. A more rounded lens produces sharper close-up views. Simultaneously, the pupils open or close, letting in more or less light. A combination of these actions on tubular (as opposed to rounded) eyes gives the eagle its excellent ability to focus far or near in varying light conditions.

Beyond these remarkable facts, even more amazing is the rate at which eagles can focus from far to near. Called accommodation, it is much faster in eagles than in people. Accommodation is what allows eagles to track fish and other objects near the surface of water and keep them in focus while swooping down at high rates of speed.

Do Bald Eagles have better eyesight than people? While eagles have sharper vision, see better in low light (light sensitivity), focus faster and differentiate color better, it is unknown how they perceive objects. Even so, it is safe to say that eagles have much better overall vision than you and me.

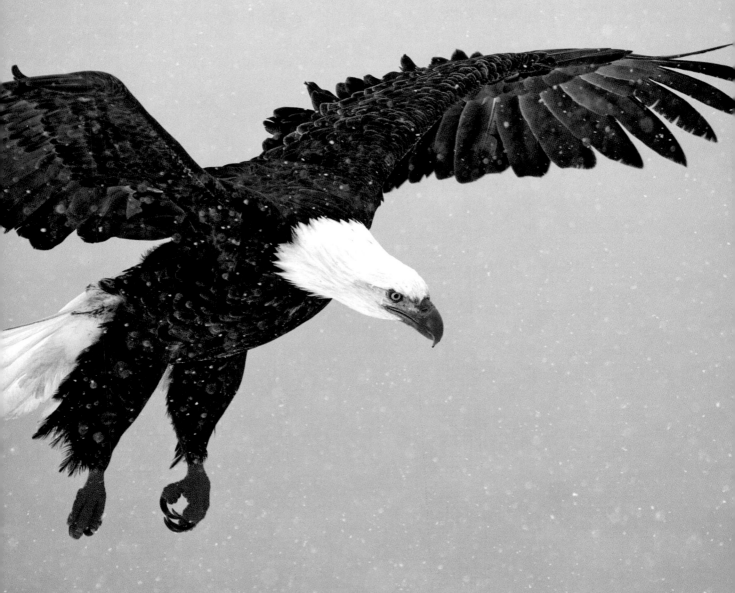

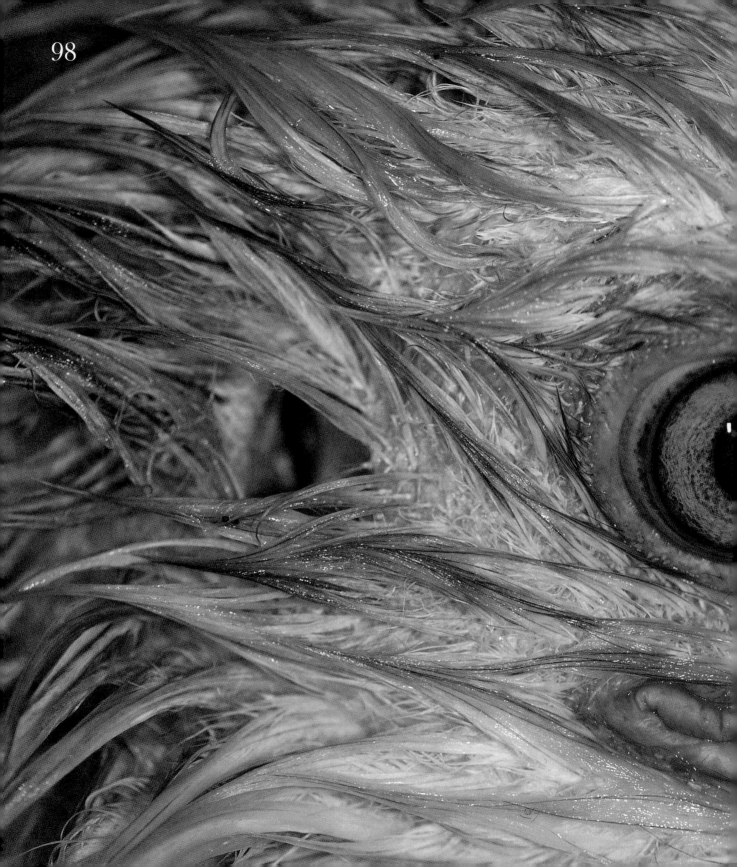

Hearing

Unlike owls, which rely greatly on hearing for hunting, Bald Eagles use hearing only initially to locate their prey. While most mammals have large flaps of cartilage and skin for external ears, an eagle just has a simple opening on each side of its head. These openings are hidden beneath feathers and not usually seen. Ear openings can be visible when a strong wind moves the head feathers or when the head gets wet. Similar to mammals, the external ear opening leads down a canal to the middle and inner ears, which is where sound is received and processed.

The function of feet

The legs and feet are truly the business end of an eagle. They are structurally lightweight, yet extremely strong. Similar to the anatomy of other birds, in eagles, what appear to be knees bent backward are actually ankles. (The knees bend the right way, but are hidden in the body feathers.) Likewise, what appear to be feet are really toes. An eagle walks on its toes with its heels (ankles) held up in the air. Try walking on your toes with your heels off the ground—this is how an eagle's feet function.

Eagles grab and kill their prey only with their feet. The foot bones are extra long and thin, which helps the eagle capture and hold prey. The scaly yellow covering over the feet, called the podotheca, protects the eagle from defensive injuries made by struggling prey. Each foot has 4 toes or digits. These have an anisodactyl toe arrangement, with 3 toes facing forward and 1 backward. The single rear-facing toe, called the hallux, corresponds to the human big toe.

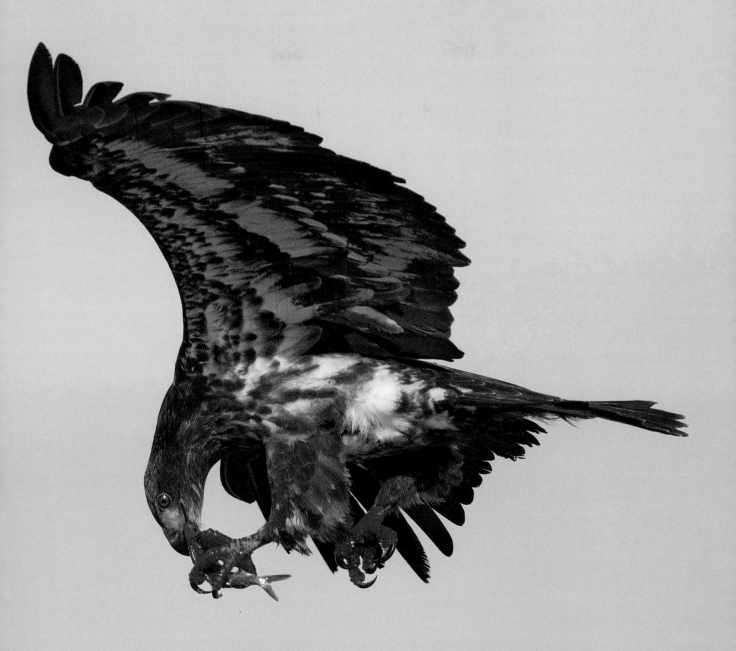

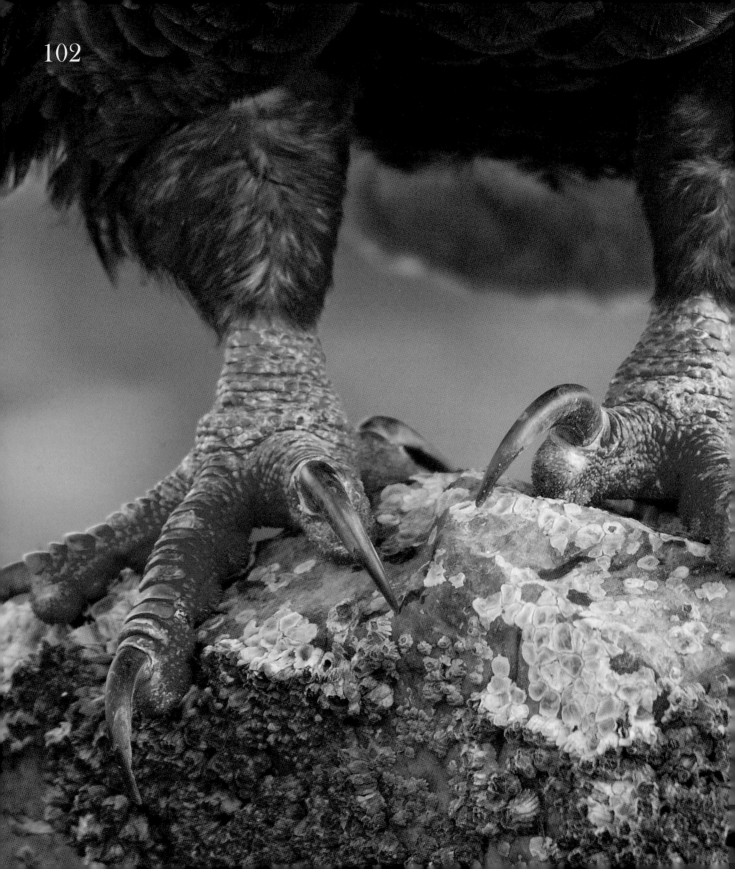

Extreme talons

At the end of the toes are extremely sharp nails or talons, which are crucial for hunting and self-defense. The thick talons of an eagle are made from keratin, the same tough substance in the bill. Like the bill, talons grow continuously. Everyday activities, such as hunting and perching, wear down talons and keep them from getting too long. Still, eagle talons can grow to an impressive 2 inches long. And while an eagle's bill looks daunting, it isn't the bill that kills—it's the talons. Eagles drive their talons deep into flesh, killing when a vital organ is pierced. Only after prey is rendered lifeless will an eagle tear apart the carcass with its bill and eat.

Eagles have the ability to close their feet with incredible force, first to hold struggling prey, then to kill it, whether fish or mammal. They also have spiny-tipped pads on the soles of their toes that help them keep a firm grasp on slippery fish. These special pads are called papillae.

Designed to fish

The lifting power of an eagle is limited to objects that weigh 4 pounds or less, making very large fish and other heavier prey too big for an eagle to kill. To catch a fish, an eagle keeps its eyes on the prey and descends to the water's surface very quickly, sometimes at speeds above 50 mph. With total coordination and at the precise moment, the eagle swings its legs and feet forward and spreads its toes in preparation for the catch. When the eagle passes over the fish, it quickly swings its legs down. During those fleeting moments, the bird loses sight of the fish and relies on touch. The instant its feet contact the fish, specialized tendons in its legs and feet cause the feet to snap shut. Immediately the bird makes the catch, sinking its talons into the fish, papillae aiding the grip.

Like other birds, eagles have great control over their feet and can hold or release objects at will. There is no locking mechanism that makes them hold onto a fish or other prey. There are many stories about eagles drowning after being dragged underwater by a large fish that wasn't released. These are fish tales and simply not true.

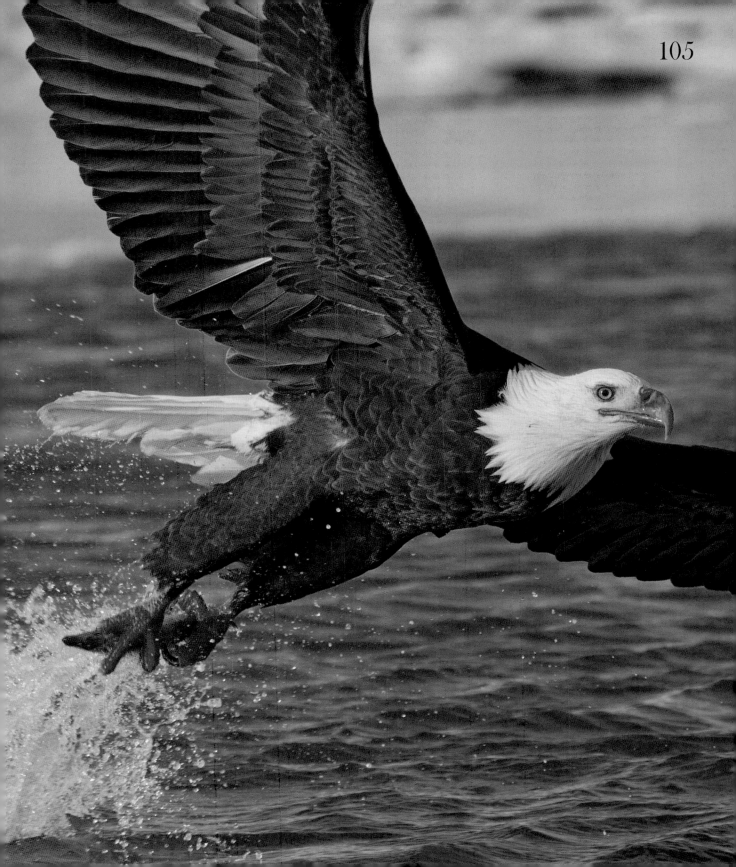

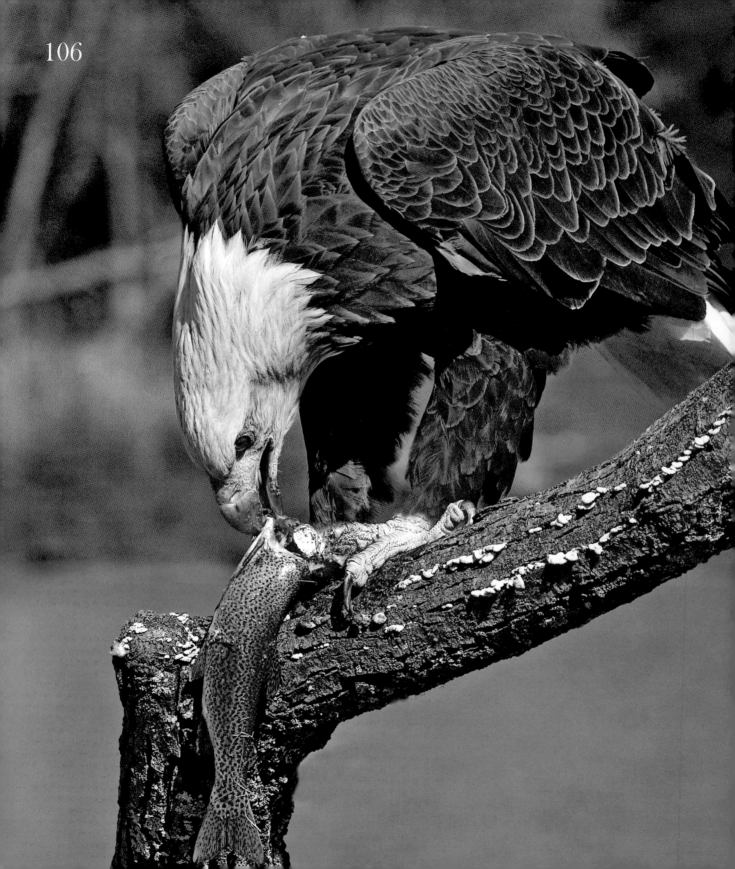

Diet of fish and more

Sea and Fish Eagle group members are top predators that eat mainly fish. With a primary diet of fish, the Bald Eagle is no exception. Those living near sizable bodies of water consume large numbers of fish.

Over the years, other Bald Eagles have gradually taken residence far from large bodies of water. Now every state in America has a thriving population of Bald Eagles, including the arid Western states that lack large lakes and rivers. Additionally, cold northern regions with many lakes that freeze during winter are seeing significant populations of Bald Eagles remaining throughout winter.

Eagles that live away from the water are feeding on small mammals such as mice, voles, squirrels, ducks and, increasingly, roadkill animals such as deer. A roadkill deer can provide much needed food in the middle of a cold and snowy winter, but with a meal on the road comes great danger. Eagles need a fairly long takeoff path, so when they feed on road kill and are frightened by a passing car, they usually fly away in the only clear direction—the open road, where they are often hit and killed.

What About Fido?

One of the most common concerns about eagles hits close to home: Will eagles eat my pet?! The short answer is: No. Eagles are large birds, sure, but they can only carry something like four or five pounds. That means they could only snatch the smallest of pups or cats. So if you see an eagle flying overhead, you don't need to bring in Fido. I'd be a lot more worried about the dog next door, or worse yet, cars.

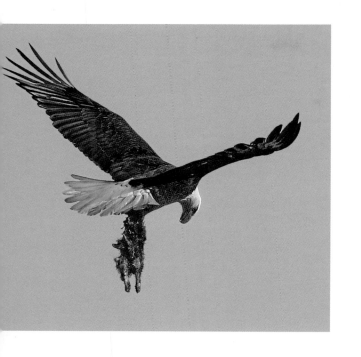

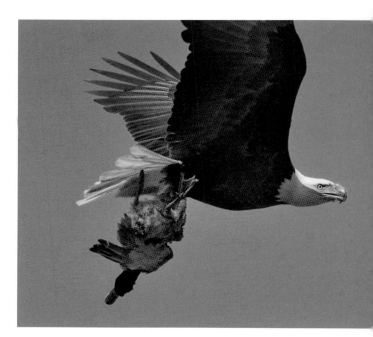

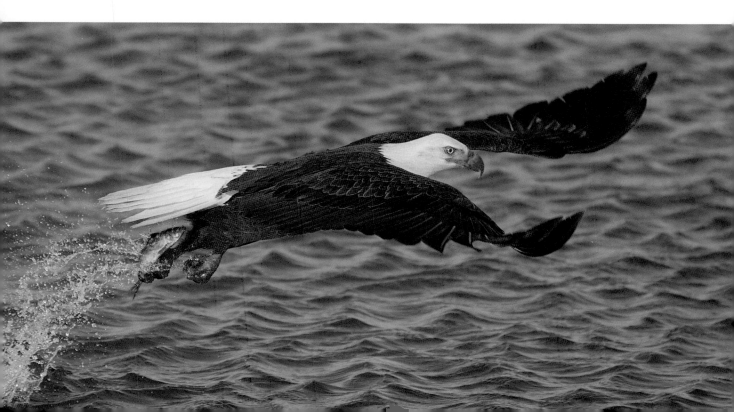

Communicating with calls

The call of the Bald Eagle is a high-pitched stuttering chirp. Both adult and juvenile birds throw their heads back to give the call or rotate their heads from side to side while calling, as if spraying the sound around in several directions.

Adult birds call to announce their territory or communicate with their mate. They will also sound off when encountering another eagle or during mealtime. When one eagle in a group calls, it often will be followed by the calls of several other eagles.

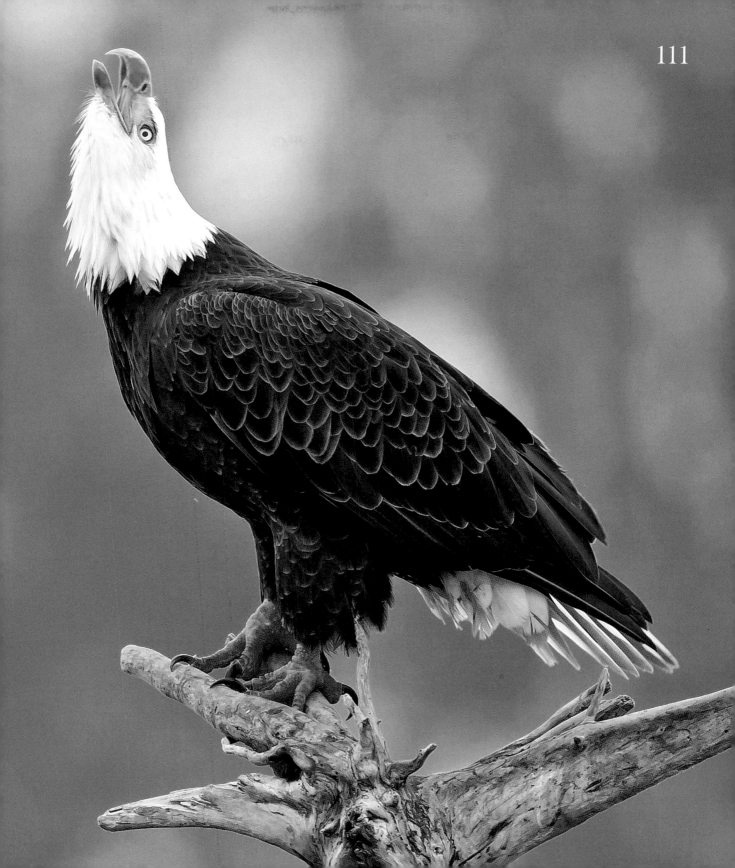

The perfect nest

The Bald Eagle is well known for its impressive large nest, known as an aerie (or eyrie). The nest site is usually high in a large tree and often near water, with an open flight line to and from the nest. Depending on the height of the tree, nests can be as low as 10 feet from the ground to up as high as 100 feet.

Nesting begins with a search for the right tree. A pair of eagles chooses one with branches large enough to support a heavy nest, often a tall White Pine. Next, the birds carry in the building materials one by one—large sticks and twigs up to 3 inches in diameter and as long as 3-4 feet. Eagles collect these from the ground or, during flight, break them off dead trees. Branch breaking in flight is accomplished by a combination of movements— flying to a dead or dying tree, grabbing a branch or twig with the feet and, with several deep, powerful wing beats, snapping the branch from the tree and flying away. Once a branch is taken to the nest, it is meticulously placed by one member of the pair.

The nest interior is lined with pine needles, grasses and other soft plant materials. Evergreen sprigs are often brought in during this time—a common practice of many species of hawks and other eagles.

While eagles usually nest in large trees, they also build on cliffs. In far northern regions where trees are short or nonexistent, nests are constructed on the ground. In the Everglades at Florida's southern tip, eagles build their nests in mangrove trees, which grow to just feet above the water line.

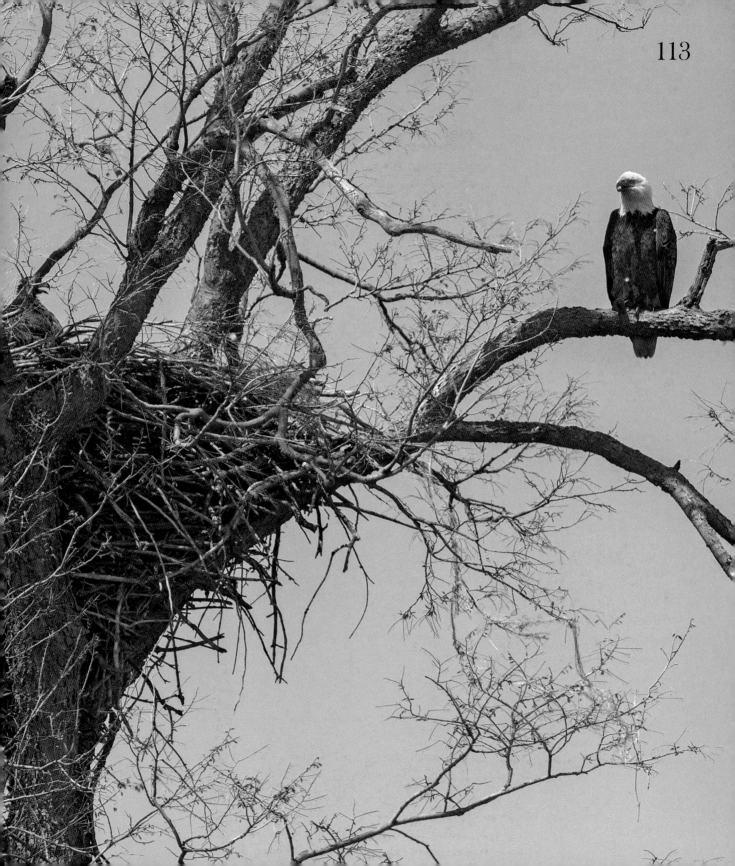

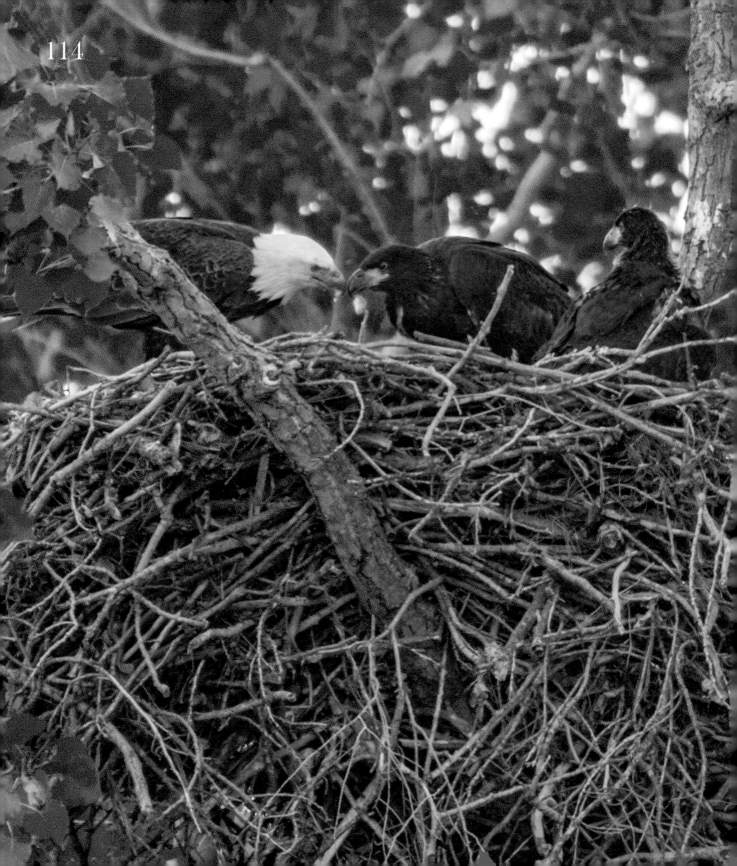

The king of nests

Bald Eagles are known to take over Osprey nests. These nests are often on power poles or other manmade structures, including bridges or even floating channel markers in large bodies of water.

A typical nest is usually around 5-6 feet in diameter and strong enough to support a human adult. Since nests are reused year after year, a pair simply adds new nesting material each season. As years pass, nests can grow to enormous sizes with the accumulation of additional branches. Some nests expand to 10 feet in diameter and reach 20 feet in height! Some of these extremely large nests are estimated to weigh over 2,000 pounds. If a large nest is in a dead or weak tree, eventually it will break apart in a storm. When the tree itself falls, the pair often rebuilds nearby.

Nest building can occur at anytime of year except during incubation. Often a pair will construct a nest in late summer or fall and add to it slowly over winter, but these efforts are not intense. When spring comes, the eagles get serious about building and put much effort into gathering materials for the nest. Sometimes a pair of eagles will use a nest for several years and then suddenly start a new one close by. The reason for this behavior is not yet understood.

Like most birds, Bald Eagles are territorial during nesting season and defend their territory by keeping other eagles away from the nest. Depending on the availability of food and density of the local eagle population, a typical territory is 1-2 square miles—larger when there is less food, smaller when there is a more consistent supply.

Nest cams

A relatively recent invention, nest cams are now a popular way for eagle fans to take a peek inside the nest. These cameras are often most popular during breeding season, when eggs and hatchlings are the stars of the show, giving birding aficionados, schoolkids, and regular web-browsers alike an up-close look at an eagle's life.

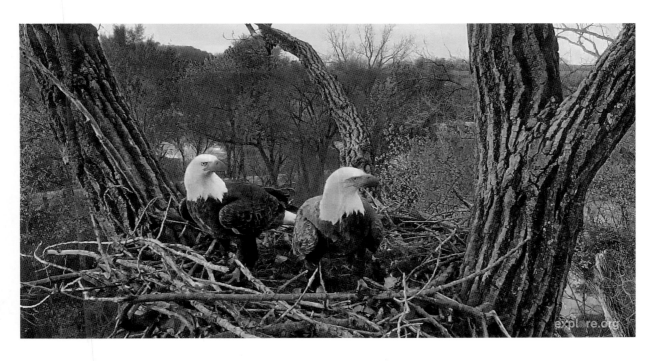

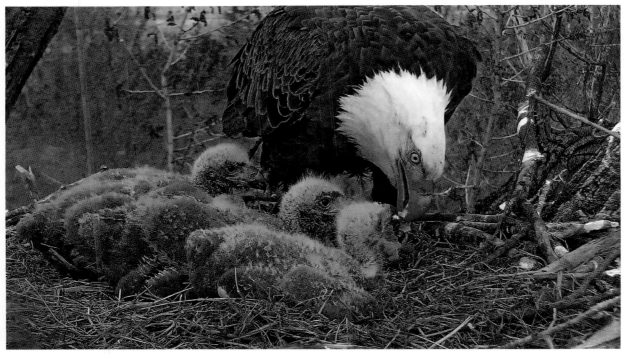

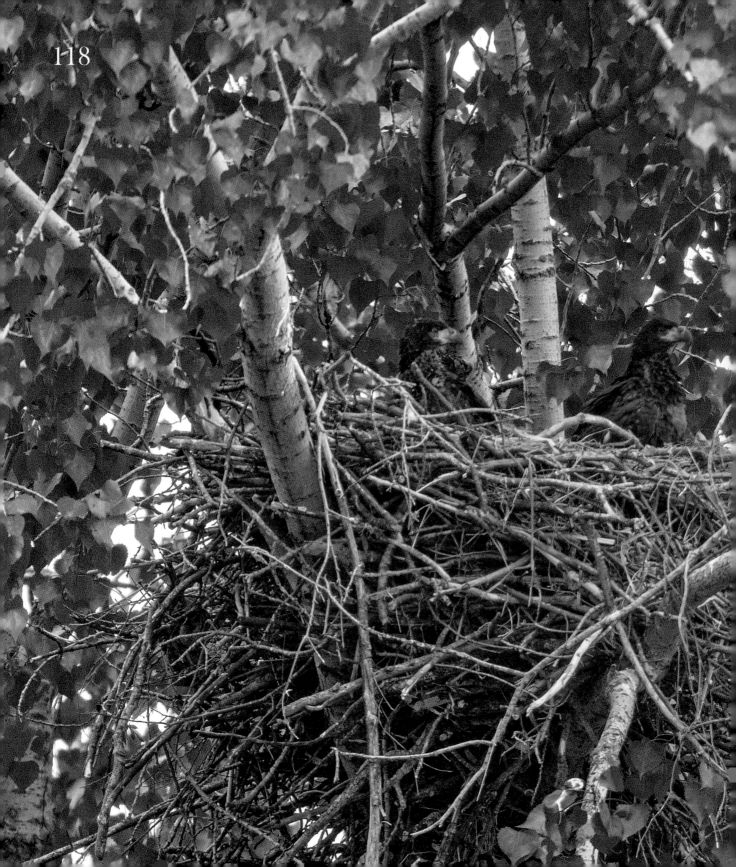

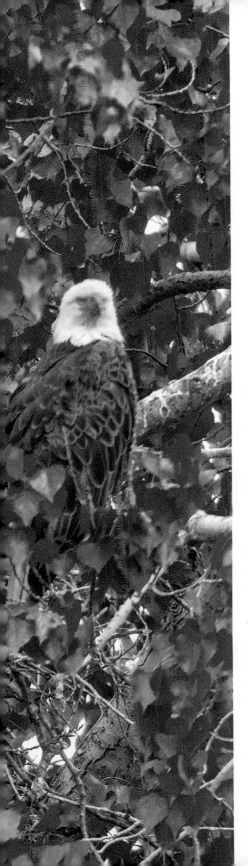

Wait, what is that eagle eating?

Before you tune in to a nest cam, be advised that you'll be getting a front view of nature. This means, it can be disheartening at times. Sometimes, eggs don't hatch, hatchlings or even adult eagles can die, and dinnertime can sometimes be somewhat unnerving. (Especially if a cute, furry critter is on the menu.) With that said, it's an unparalleled way to see eagles from a vantage point impossible to get otherwise. And don't worry, domestic pets are rarely, if at all, on an eagle's menu.

NEST CAMS TO CHECK OUT

- Decorah Iowa Eagle Cam 1
- Decorah Iowa Eagle Cam 2
- Dollywood Nest Cam
- National Arboretum Nest Cam
- Smoky Mountain Nest Cam
- Welaka Nest Cam
- National Eagle Center
- Hanover Bald Eagle, PA
- N.E. Florida Nest Cam
- Minnesota DNR Eagle Cam

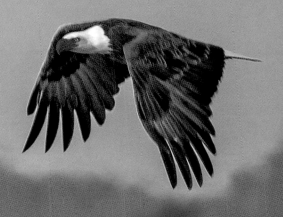

Picking a mate

Bald Eagles don't start mating until after they obtain adult plumage at approximately age 5. While Bald Eagles are known to mate for life, the concept of mating for life is different from the popular perception. Studies have shown that the fidelity of eagles is to the nest site and territory, not to a particular mate. Since only two birds can be committed to one nest, the eagles returning to a nest site will mate with each other. Having said that, it has been well documented that three eagles have attended one nest and brood of chicks.

Pairs stay together as long as nesting attempts are successful. Pairs that are unsuccessful at raising young often separate to find a new nest site and mate. Parents that raise young effectively remain together as long as both can reproduce.

Sometimes one member of a pair will be much older than the other. As an eagle ages, its reproductive ability decreases and eventually stops. When this occurs, the younger of the pair will take another mate and continue to breed.

When one mate dies, the surviving bird finds a new mate and resumes breeding. Sometimes a stronger or more dominant eagle will challenge a resident of the same sex for the territory. Fights can last from 2 hours to 2 days, with the victor taking residency and the opportunity to breed. Meantime, the onlooker mate does not help drive off the intruder, but sits in wait for the best outcome.

Mating season varies from north to south. Eagles in northern states begin mating season in January and February, while in the far reaches of Canada and Alaska the season is delayed until March. In the South, mating may begin during November or December.

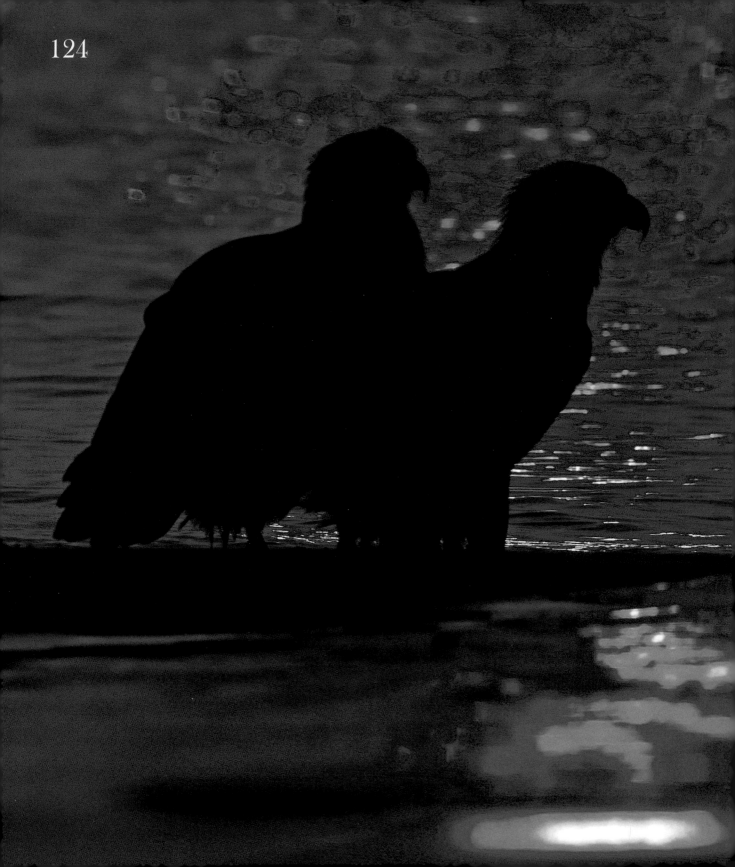

The courtship ritual

Eagle courtship is a spectacular sight! Each year a pair courts anew, even when the birds have stayed together for many years. In late winter and early spring, a mated pair will fly together high into the sky. There they will chase each other in what is called a pursuit flight, diving and pursuing one another in seemingly playful behavior. During an aerial chase, the eagles approach one another, legs extended outward with toes spread, and one bird will suddenly flip upside down to grab the other's feet. When their feet interlock, the pair starts to tumble or spin downward toward the ground.

Sometimes the birds appear to be like a helicopter spinning out of control. Other times they look like a rolling ball, tumbling down through the air in what is called a cartwheel. The tumbling and spinning can last just a few seconds or continue for up to a minute, depending on the height of the birds at the start. Eventually they release their grip and pull out of the tumble, gliding off on outstretched wings, returning to do it all over again.

Why eagles perform this astonishing maneuver is unknown. It could be a form of ritualized battle that proves a mate to be a strong and worthy partner. In any case, the courtship builds their nuptial bonds.

Growing into the mating years

Eagles start being capable of reproduction between ages 4–5. Since they can live up to about 30 years, it is possible for them to reproduce for more than 20 years. Most eagles don't pair off and reproduce until they are 7–8 years of age. Even after mating for several years, for whatever reason, some eagle pairs do not reproduce in a given year. This may be due to a lack of food or nesting sites, the presence of parasites or just plain bad timing. Fortunately, these pairs often become successful at reproduction in subsequent years.

Young eagles often participate in courtship behavior. Aerial performances may be serious practice for the time when a mate is needed, or they might just be fun to do. Some believe the birds are displaying typical teenaged eagle behavior, engaging in dramatic feats of flight that they are not supposed to do. We'll never know.

While courtship takes place in the air, copulation occurs when the birds are perching. Mates sit very close to one another on a branch, where they groom each other's head feathers and maybe also touch beaks. When the time is right, the male steps onto the back of the female as she leans forward into a horizontal position. Lifting and twisting her tail, she reaches up to encounter the male. When the reproductive openings (vent or cloaca) of both birds touch, a packet of sperm passes from the male to the female. This process lasts just a few seconds, and the male rejoins the female on the branch. A pair may repeat this many times until the time comes for laying eggs.

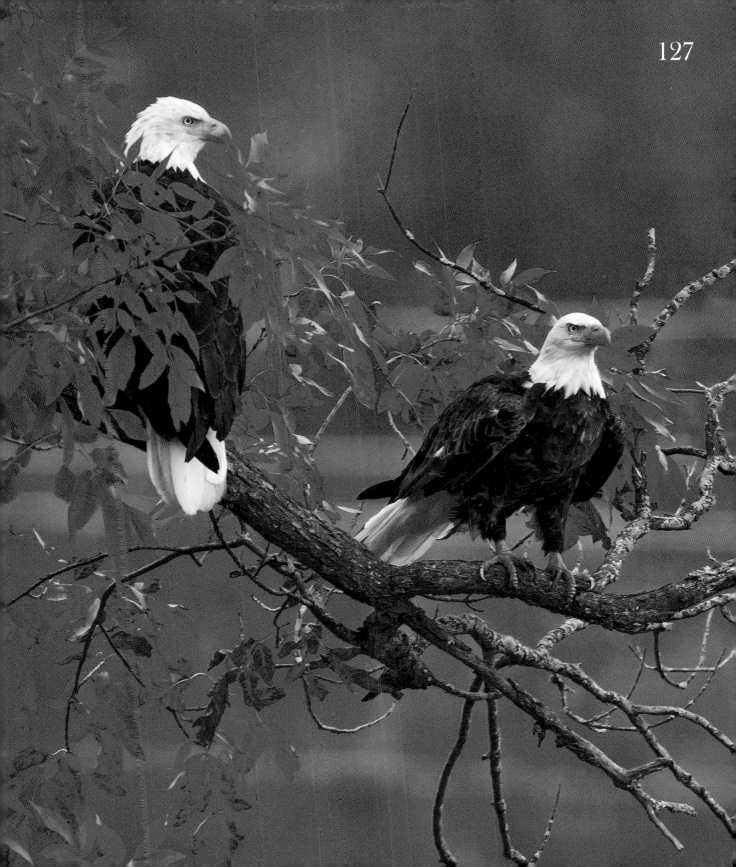

Eggs and incubation

A female eagle is ready to lay eggs 5-10 days after successful copulation. Eagles produce 1-4 eggs, one at a time in 2- to 3-day intervals. The second egg is often laid 2 days after the first egg, sometimes 3 days later. When a third egg is produced, it is laid after several more days. A clutch of 4 eggs is very uncommon.

An eagle egg is large, about the size of a goose egg—around 4 inches from end to end—and off-white. Since eagles are top predators that nest in inaccessible places, their eggs are quite safe without camouflage colors or markings to conceal them. Eggs are nearly round, not tapered like chicken eggs.

Sharing incubation duties

A female eagle starts to incubate as soon as she lays her first egg. Incubation lasts over a month, from 34–36 days. While incubation duties are shared by both parents, the female does the most sitting. The male brings food to the female while she incubates, leaving it at the nest or on the ground nearby. When the female leaves the nest to feed, the male incubates for a while. After feeding, the female may go for a short flight to stretch her wings and defecate away from the nest site. In northern latitudes where spring weather can be downright cold, the eggs are rarely left unattended. An eagle egg can withstand some cooling, but freezing will kill the developing embryo.

Some males bring fresh evergreen or deciduous tree branches to the nest during the incubation period. Unfortunately, there is no good explanation for this charming behavior. Some speculate it helps diminish nest odor, but since eagles don't have a well-developed sense of smell, this isn't logical. The branches could be used to reduce the number of insects or perhaps provide shade or shelter for the newly hatched young. Or, it may just be a nervous response of the male to the long incubation process.

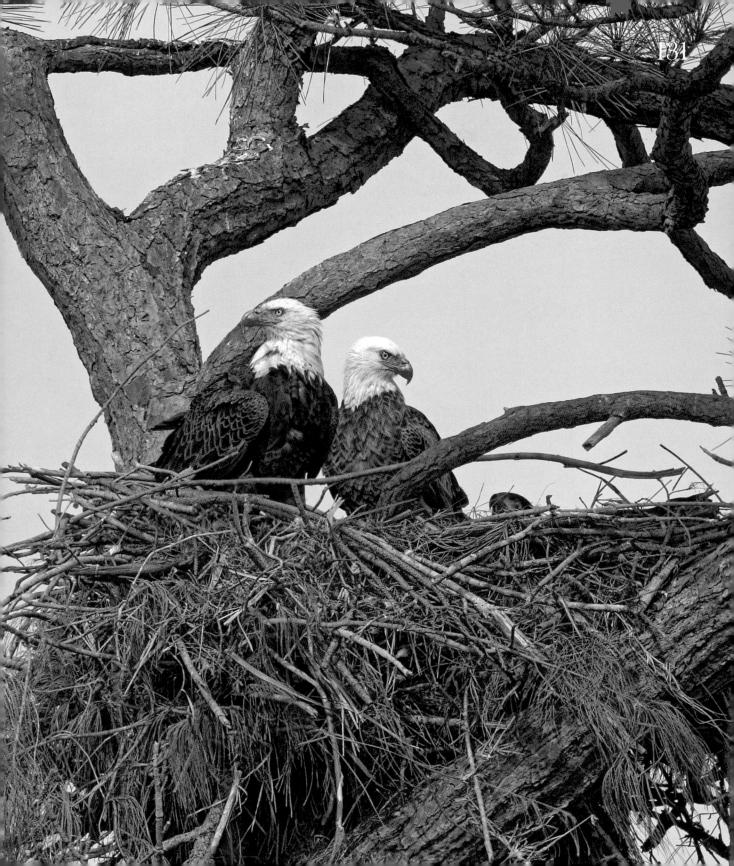

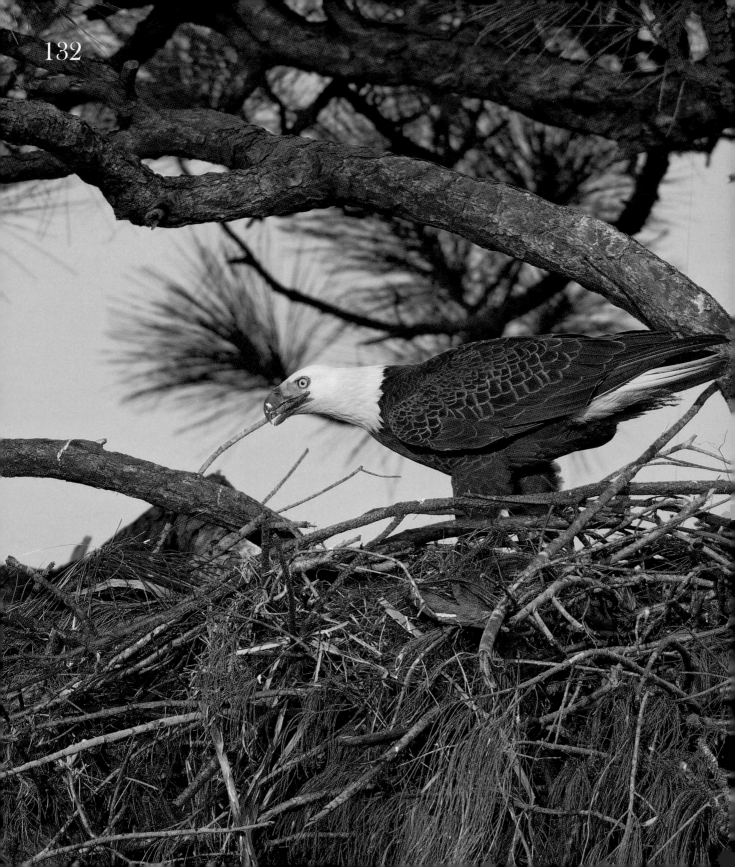

Hatching

Eggs hatch in the order in which they were laid, which results in one chick being 2–3 days older than the next. When there is a third chick, it can be up to 1 week younger than the oldest chick. Eggs hatching over a period of several days is called asynchronous hatching.

The hatching process can take up to 48 hours. An eaglet breaks through its shell (pips) with a specialized projection on the tip of its upper bill. This protrusion is called an egg tooth, but it isn't a tooth at all. Well-developed muscles in the neck help an eaglet push or rub its egg tooth against the inner surface of the eggshell. Repeated rubbing in one place with the egg tooth wears a hole in the shell. When the hole gets big enough, the eaglet emerges and the egg tooth falls off shortly thereafter.

Life in the nest

Newly hatched chicks are undeveloped (altricial) and completely dependent upon their parents. They are covered with only a thin layer of tiny whitish-to-gray feathers and are unable to regulate body temperature. In addition, with weights of just 3–4 ounces, they are too weak to lift their heads and cannot eat for the first 2 days of life. Instead, they are sustained by nutrients previously absorbed from the egg yolk sac. Female eagles brood the chicks during this critical time, sitting on them to keep them warm and safe.

At first, the adult male brings all food to the nest for the newly hatched young and new mother. Chicks are fed tiny bits of food by their mother, who tears up the larger pieces of food for them. Since baby chicks tire quickly, the mother will offer morsels to them over and over until the food is taken. If any cuisine is rejected, the mother eats it. Only when chicks get larger do the males perform some of the feeding.

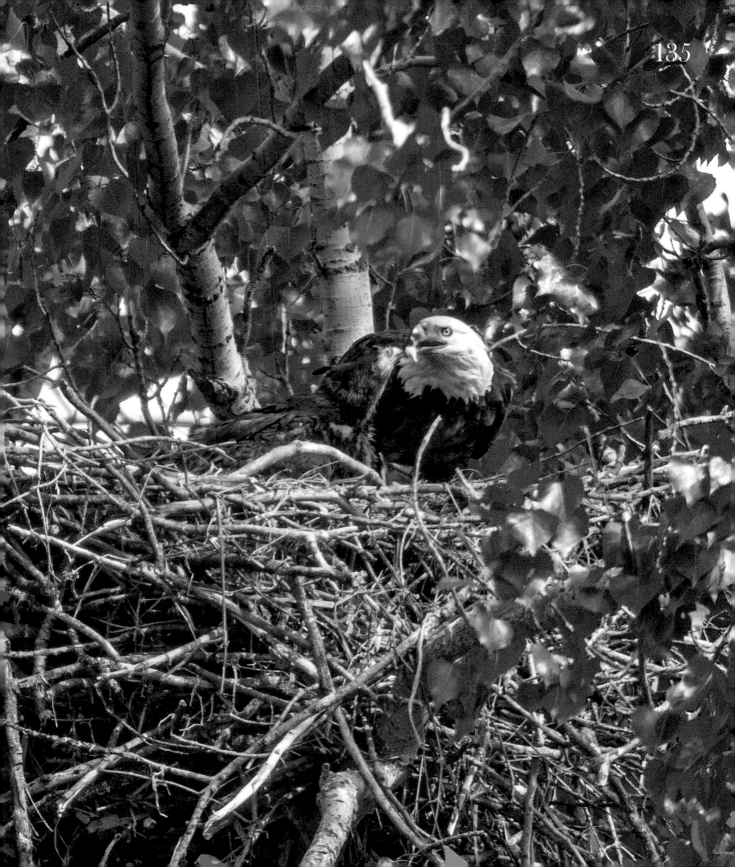

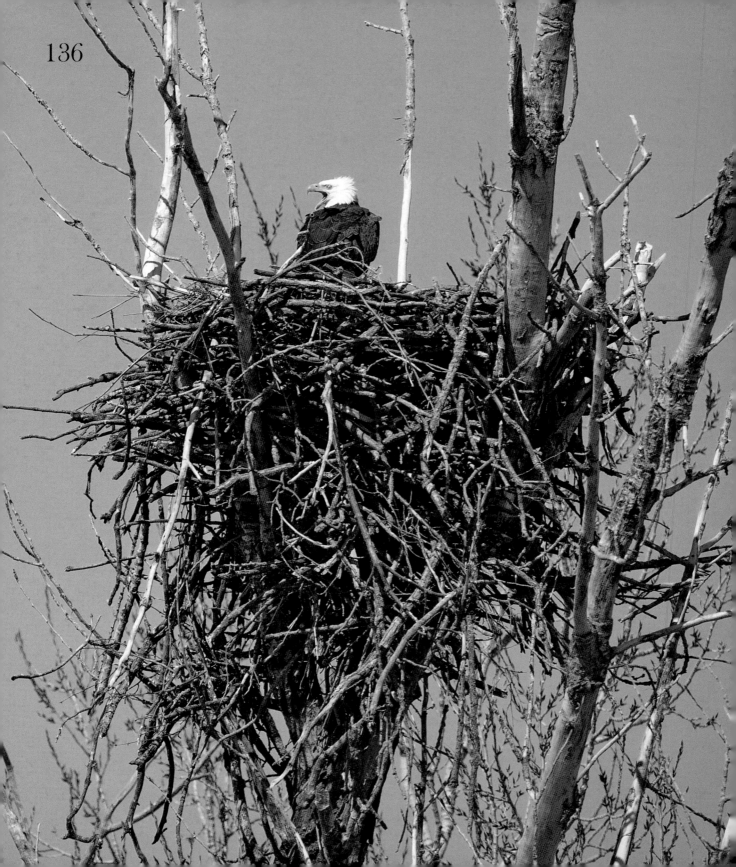

Growing up quickly

Eaglets grow very quickly on their high-protein diet of fish and other meats, gaining up to 1 pound of weight each week. At about 2 weeks of age, they can hold their heads up for long periods of time, which enables them to eat more often. By the third week, eaglets are nearly 1 foot tall. With well-developed bills and feet, they are feeding themselves, eating food left at the nest by their parents. At this point, the parents are not spending much time at the nest, but will sit nearby in a tree. Between 4-5 weeks, the young can stand and move around the nest. They are nearly fully grown by about 6 weeks, covered with dark feathers and sporting a large dark bill.

From nest to flight

Starting at 8 weeks, young eaglets begin to test their wings by standing at the edge of the nest and flapping. With the aid of the wind, they often can lift off briefly, touching down on the nest after a few moments in the air. They also spend a lot of time preening their feathers and looking around, familiarizing themselves with the surroundings—their home for the next couple months. During most of the final weeks in the nest, young birds play tug-of-war with each other, using sticks and remains from previous dinners. The parents don't spend a lot of time at the nest anymore except to drop off food, perhaps only 1–2 times each day. Chicks take their first flights between 10-12 weeks of age. The first flights are usually short, to a nearby tree or cliff face. Sometimes they land on the ground, where they may stay for a day or until they gain enough strength to fly up into a tree. Once eaglets leave the nest, they usually don't return. At one time it was believed that the parents would withhold food to encourage the young to leave the nest, but there is no such master plan. The young simply leave the nest when the timing is right.

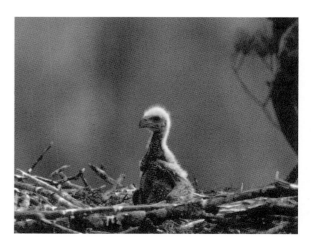

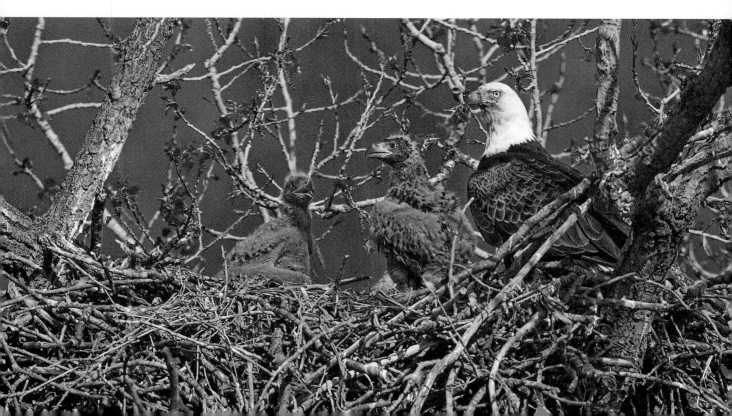

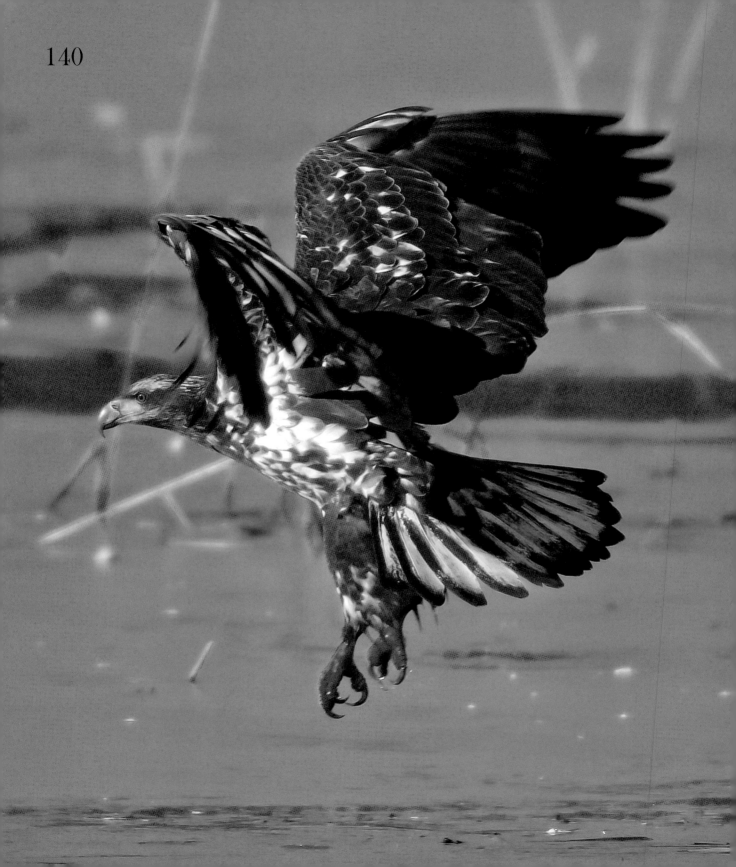

A tough beginning

Nearly 50 percent of young eagles don't survive their first year. Occasionally some young are killed while still in the nest by older, more dominant siblings. This is called obligate siblicide. Why this occurs is hard to determine. It may be relative to the availability or lack of food, or it may simply be that the older sibling is innately more aggressive.

Cold, wet weather in early spring is another killer of young eagles. Cold and wet conditions rob young birds of heat and energy, leaving them too weak to eat. Affected birds slowly die due to hypothermia and malnutrition. This usually occurs in the first few days after hatching. Leaving the nest is another critical time for young eagles. Many are killed due to injuries sustained while learning to fly. Young eagles have been found wedged between branches, caught in power lines or hit by cars.

Learning to fly and hunt

While young eaglets may not return to the nest after they fledge, they will stay around the home territory for the entire summer. Eagle parents follow their young around, bringing them a constant supply of food. Young eagles will often perch in a tree for many hours and call loudly when they see their parents returning with a meal.

Learning to fly is difficult, but learning to catch prey is even harder. Like many other top predators, it takes a long time to hone the skills needed to snatch a fish from just below the water's surface or to capture a duck. Juvenile eagles will follow their parents around to see how it's done and then practice their new skills repeatedly until they are stronger and skilled enough to do their own hunting.

After learning to fly, young eagles remain with their parents for 10-15 weeks. At just 4-5 months of age, the young leave their natal homes to begin life on their own, often spending the winter with other eagles along major rivers where fishing is possible. Over the next 5 years, juvenile eagles move around from place to place, usually staying around other juveniles until they are old enough to look for their own territory and mate.

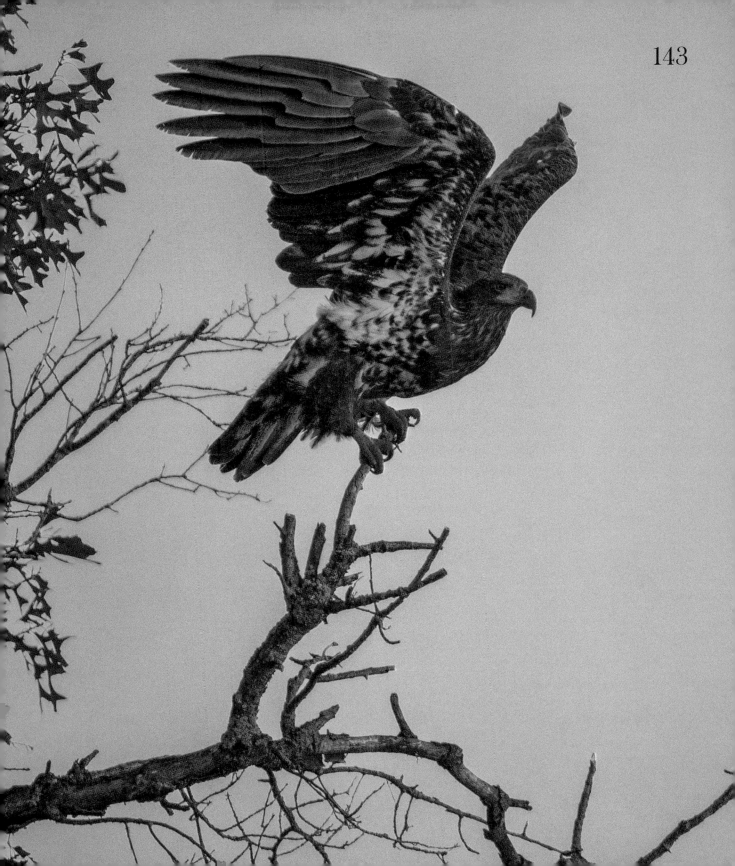

Getting through winter

Winter can be a very difficult time of year for young eagles. No longer defending territories, eagles of all ages gather along open bodies of water such as below dams or at warm water discharges from power plants. Here adults feed on fish and any waterfowl they can catch. Young birds scavenge leftovers from more experienced eagles and learn how to steal fish. Fights do occur, but injuries are rare.

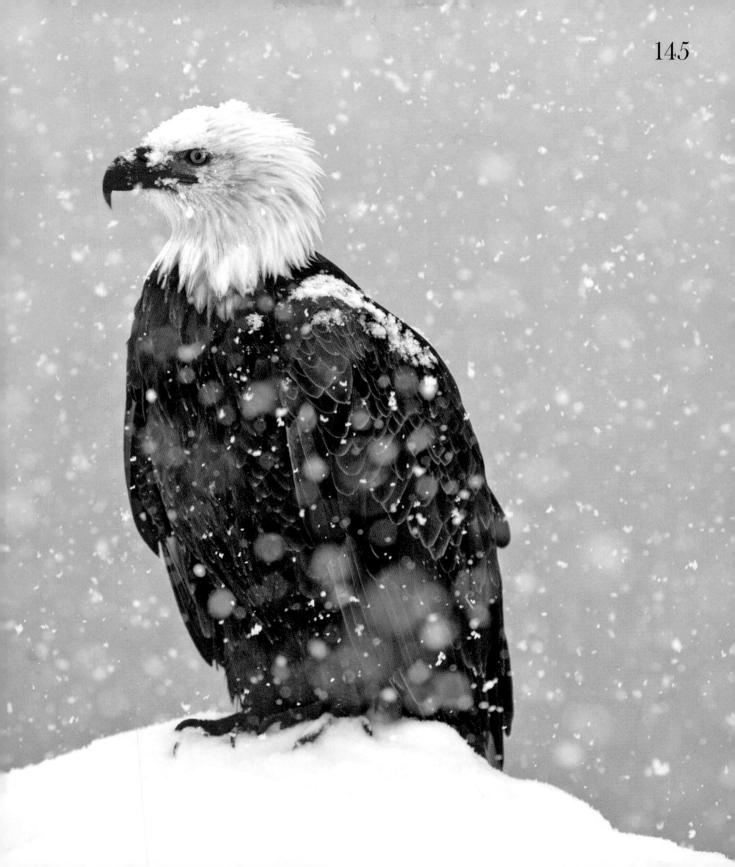

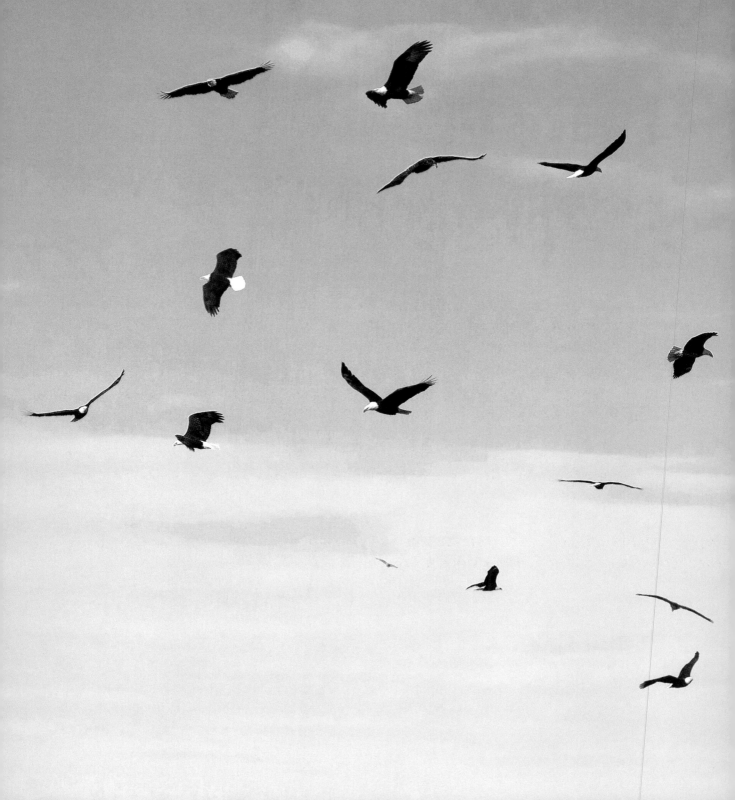

The rigors of winter

The rigors of winter take a toll on eagles of all ages. As long as the food supply lasts, eagles spend winter days sitting in trees, conserving energy. When they become hungry, they head off to find something to eat, then return to resting.

On clear days when winds are light, eagles often soar high in the air. Sometimes groups of 10 individuals or more can be seen catching the few rising thermals that some winter days offer. Soaring high must be exhilarating for the birds, as they stretch out their wings after long hours of still, quiet perching. During late winter, pairs begin their aerial displays and courtship flights in preparation for the coming mating season.

Winter nights are spent in the shelter of trees, perching with feathers fluffed to trap as much insulating air as possible. With the first rays of the morning sun, another splendid day of the eagle starts all over again.

Eagles can be very sensitive to disturbances within their roosting areas on winter nights, even though they can appear oblivious to human activity during the day.

Migration

Migration is based on the availability of food, not cold weather. When an eagle can find a constant food supply all winter, it does not migrate. In central and southern regions of the United States, eagles usually just congregate along rivers and lakes instead of migrating, gathering in small to large groups. In northern states and Canada where most lakes freeze, many eagles move to places with open water, usually major waterways such as the Mississippi and Missouri Rivers.

Migration occurs during the day. Bald Eagles fly in small groups or individually at average speeds of about 30-40 mph. They take advantage of thermals to propel them effortlessly during migration, helping them along their way.

Eagles rest during the night and will continue migration the following day when the weather cooperates. Cold and rainy days are not good for migrating, so on frigid or wet days, eagles wait until the weather changes. Winds from the north can be very helpful in moving eagles along their migratory route, but strong winds from the south cause the birds to cease flight until the winds subside.

Eagle
Hotspots

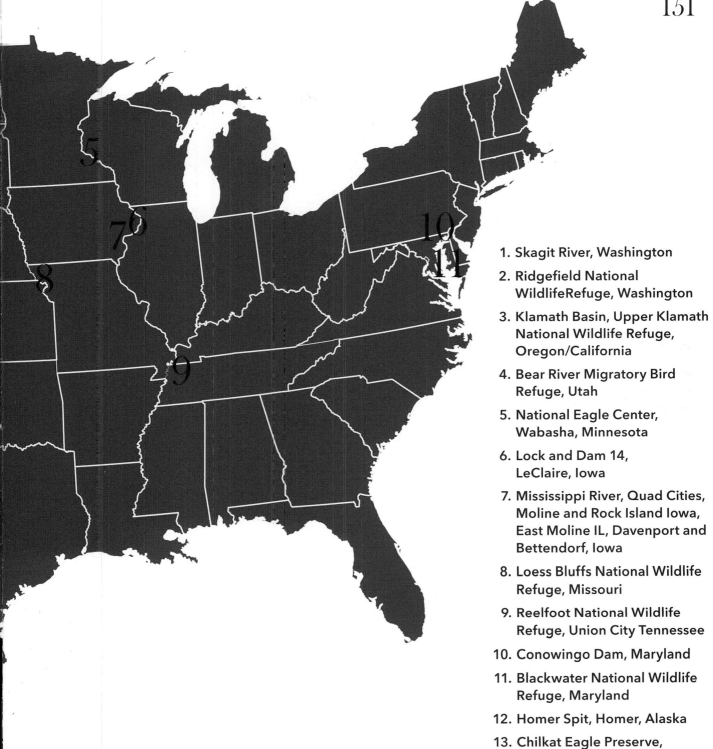

1. Skagit River, Washington

2. Ridgefield National WildlifeRefuge, Washington

3. Klamath Basin, Upper Klamath National Wildlife Refuge, Oregon/California

4. Bear River Migratory Bird Refuge, Utah

5. National Eagle Center, Wabasha, Minnesota

6. Lock and Dam 14, LeClaire, Iowa

7. Mississippi River, Quad Cities, Moline and Rock Island Iowa, East Moline IL, Davenport and Bettendorf, Iowa

8. Loess Bluffs National Wildlife Refuge, Missouri

9. Reelfoot National Wildlife Refuge, Union City Tennessee

10. Conowingo Dam, Maryland

11. Blackwater National Wildlife Refuge, Maryland

12. Homer Spit, Homer, Alaska

13. Chilkat Eagle Preserve, Haines, Alaska

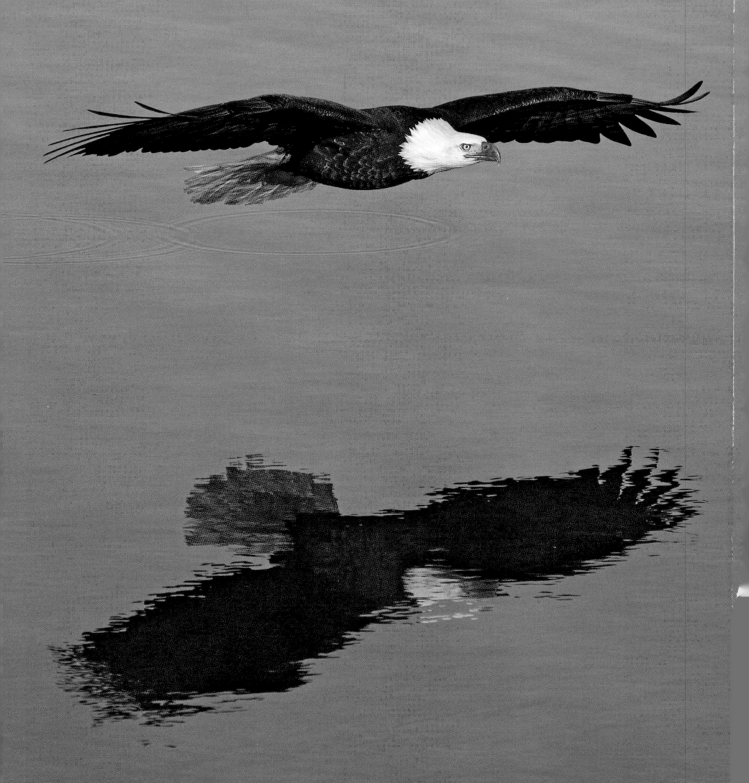

Returning home

Once the eagles reach their wintering grounds, they usually remain there for the rest of the season. At the first hint of spring, the birds return to their home territory, even before the ice melts from area lakes.

When young eagles reach breeding age, they abandon their nomadic lifestyle and often return to locations close to their natal range. Adults usually don't allow intruders into their territories, not even their own young, so newly mated young birds look for a territory nearby, usually within 10–20 miles. Some birds, however, take a mate far from their home range and never return to their birthplace. This helps mix the gene pool, ensuring a strong and healthy population of eagles.

The majesty of eagles

The majesty of the Bald Eagle has captured the attention of people for thousands of years. In the past, we regarded the eagle as competition for food and reacted by systematically killing it. We have poisoned the species to near extinction and, more recently, have come to regret the error of our ways. We have also, finally, witnessed the remarkable recovery of the Bald Eagle.

I would be hard-pressed to find anyone who doesn't agree that the Bald Eagle is, without a doubt, a majestic bird. I have spent countless days, weeks and years studying and photographing Bald Eagles, and I feel there is hardly a more photogenic bird on the planet. While my sentiment for this bird runs deep, I'm sure many of you feel the same. It is because of this widespread affection toward our national symbol that I am confident the future of the Bald Eagle will stay as bright as our nation and as wonderful as the people who care for this bird.

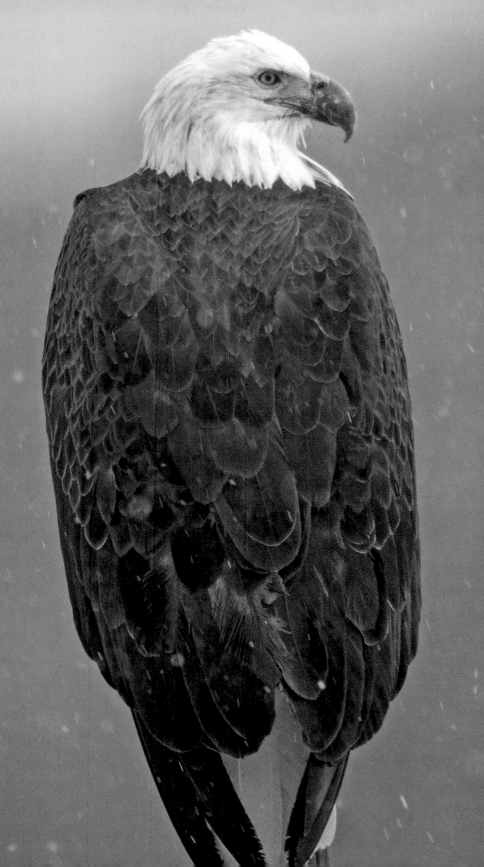

About the author

Naturalist, wildlife photographer and writer Stan Tekiela is the originator of the popular Wildlife Appreciation series that includes *Cranes, Herons & Egrets*. Stan has authored more than 190 educational books, including field guides, quick guides, nature books, children's books and more, presenting many species of animals and plants.

With a Bachelor of Science degree in natural history from the University of Minnesota and as an active professional naturalist for more than 30 years, Stan studies and photographs wildlife throughout the United States and Canada. He has received national and regional awards for his books and photographs and is also a well-known columnist and radio personality. His syndicated column appears in more than 25 newspapers, and his wildlife programs are broadcast on a number of Midwest radio stations. You can follow Stan on Facebook, Instagram and Twitter or contact him via his website, naturesmart.com.